The Dog

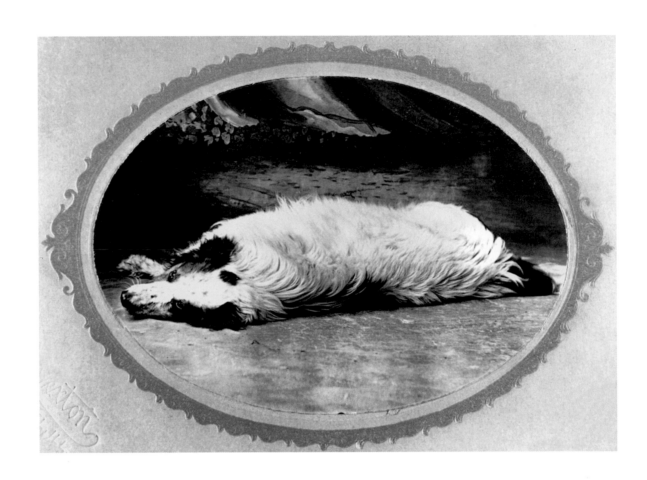

Photographer unknown, *Untitled*, c. 1900

Edited by
Ruth Silverman

The Dog

100 Years
of Classic Photography

CHRONICLE BOOKS
SAN FRANCISCO

Pages 158–159 constitute a continuation of the copyright page.

Library of Congress Cataloging-in-Publication Data available.

ISBN 0-8118-2911-1

Designed by Jody Hanson.

Printed in Hong Kong.

Distributed in Canada by Raincoast Books
9050 Shaughnessy Street
Vancouver, British Columbia V6P 6E5

10 9 8 7 6 5 4 3 2 1

Chronicle Books LLC
85 Second Street
San Francisco, California 94105

www.chroniclebooks.com

For dear Lumière (page 6) and Jeff (page 156)
and dear departed Jessie, Noodle, Tomato, Wanda, Mickey, Mitzi, and Fuzzy.

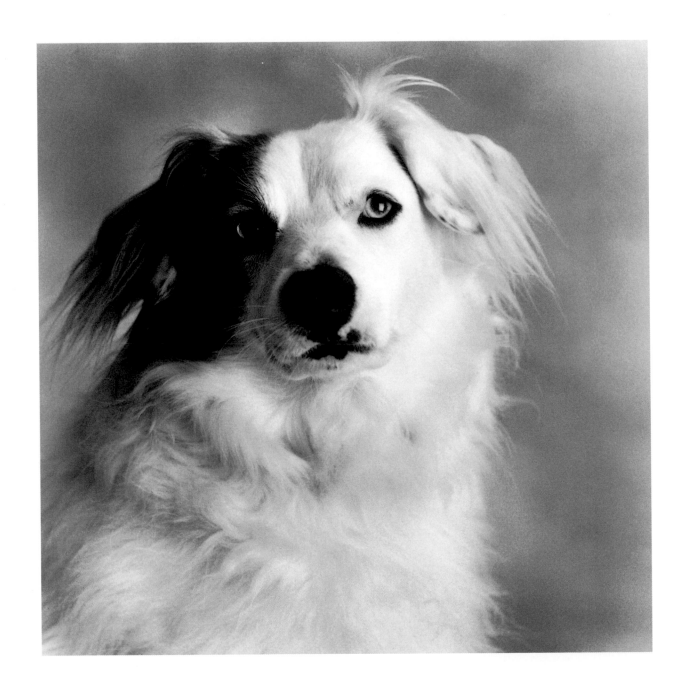

Valerie Shaff, *Lumière*, 1998

Introduction

This book is a survey of the art of photography during the twentieth century. The theme of the photographs is the dog. In viewing the material it is easy to focus on the subject, especially a subject so adored, so appealing, and so frequently amusing, but it is hoped at least equal attention will be paid to the photographs themselves, their composition and light, and to the photographers (each as unique as each dog) who made them. What did the photographer see, and how did he see it? So, while enjoying this book, keep in mind the simple guidance offered by photographer Elliott Erwitt that "these are not dog pictures, but dogs in pictures."

In the early 1980s, when I first assembled a group of photographs for *The Dog Observed*, this book's predecessor, my purpose was to compile an inviting history of photography by publishing in one place as many good photographs of the dog as I could find. I included work from William Henry Fox Talbot, the mid-nineteenth-century inventor of photography, through snapshots and photojournalism, and on to William Wegman and the last word in fine-art photography.

While this new collection concentrates on work of the latter half of the twentieth century, it also includes some earlier work, much of it by small-studio photographers and amateurs who, either through skillful care or by delightful accident, created excellent images. Their work has led us to the professional and fine-art photographers of our time.

The photographs in this book have been gathered from individual photographers, art galleries, museums, libraries, and private collections, and the selection reflects the editor's purpose, judgment, sensibilities, and affections. The images are generally sequenced chronologically, although liberties were taken in order to make the visual presentation of the whole as appealing as possible. In some cases, an individual artist is represented by more than one photograph. Those photographs may appear consecutively or not, according to dates and/or aesthetic considerations.

No book of this size can include every striking image of its subject available, and this second volume offers the opportunity to feature some superb photographs that existed but did not appear in *The Dog Observed*. Among these are Clemens Kalischer's classic 1950s image of a boy and his puppy from *The Family of Man*, Henri de Chatillon's striking blue-eyed hound, and two compelling works of dogs in wartime by the legendary photojournalist Robert Capa. Doing a sequel also seemed a good way to include more of the wise and witty photographs by the frequent dog observateurs Robert Doisneau and Elliott Erwitt, both of whom had too much good work to include in one book. Doisneau, the great French romantic photographer, very often captured the little dogs who accompany their people everywhere in Paris. Erwitt's prolific sideline activity, making "dogs in pictures," runs simultaneously with his career as an acclaimed magazine and corporate photographer.

Since the publication of *The Dog Observed*, throngs of new photographers have come to maturity, many of whom use dogs as central in their art. Leading the way was the painter/video artist/photographer William Wegman. For more than two decades, his weimaraners, Man Ray, Fay Ray (now with a book of her own), Battina, Chundo, Chip, et al., have provided subtle gray canvases on which the artist plies his indefatigable imagination. Dressed up or collaborating on some unlikely concept, these dogs have appeared in numerous museum and gallery exhibitions, as well as in an array of creative children's books, postcards, and advertisements featuring this good-humored family.

Other photographers for whom dogs are a favorite subject are Keith Carter, Michel Vanden Eeckhoudt, and Robin Schwartz.

Schwartz is a social scientist/artist posing as a dog photographer. Her entire oeuvre concerns animals, and her focus is on the lives of domestic animals in the environments offered by their human managers. While some of her pictures are amusing, her view is often a stark and disconcerting one that speaks clearly about some of the questionable values of our society.

Carter loves to photograph the dogs whose paths cross his. Many of his compelling images are a bit disturbing, suffused with a spiritualism and something of the occult often associated with the rural South where most of his subjects are found.

In his book *Chiens*, Belgian documentary photographer Michel Vanden Eeckhoudt shows dogs often more wild than domestic, caged or on the loose. A fine graphic sense makes his work especially strong.

Each of these photographers deserves, and has, a miniportfolio in this book.

While only a few photographers focus exclusively on the dog as subject, many others feature them in some of their works. Landscape and documentary photographers, photojournalists, fashion and portrait photographers have all made a dog photograph or two along the way. Bill Dane's motorcycle-riding wolfhounds may well be his only photograph of dogs, but it is a fine example. There is the one-time-only opportunity taken by William Heick when he came across the perfectly framed dog and cat. That the dog's tail gave a little wag at the moment of exposure is photography's telltale sign of spontaneity. Leo Holub was not looking for dogs to photograph, yet a number of the artists he photographed for the Anderson Collection (of 20th Century American Art) showed up with one. It is especially nice that two of the artists in this book are painters who also use their dogs as subject matter; Roy De Forest paints almost nothing else.

In addition to photographs in which the dog is the obvious focus, this volume includes several delightful examples of the specific hidden within the whole. The photographs of Gary Hallman, Thomas Roma, and Paul Andrew Wegner, in whose images one has to find the dog, make this book a particularly interactive one.

To work with dogs, a photographer must be a master of the "decisive moment." No dog, no matter how much it cares to please, has the slightest interest in the camera. It looks down when it should look up, it turns its back, it leaves the set. Pleas to sit, stay, and stop that scratching have no resonance. The photographer must be fast and nimble—like a cat.

And there is no special interest among fine photographers in dogs of either good breeding or good behavior. The purebred and the well behaved appear in artwork only by happenstance. Any dog, under the right circumstances, is as thoroughly attractive to the artist (or to a fellow canine) as any other. When the light is good and all the elements are in place, the artist makes the picture.

So here they are, dogs everywhere, shown going about their doggy business as the photographer goes about the artist's business of looking, seeing, and preserving a perfect moment.

—Ruth Silverman
 Berkeley, California

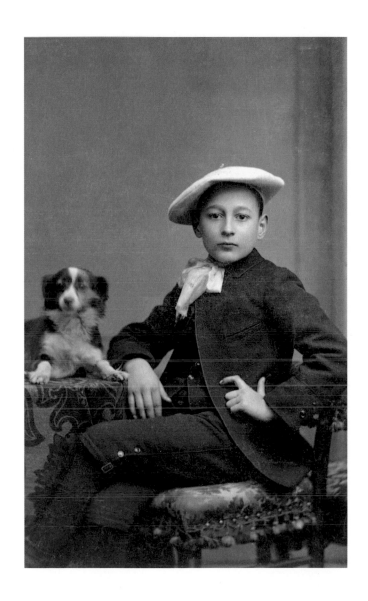

L. Jourdan, *Untitled*, Voiron, c. 1900

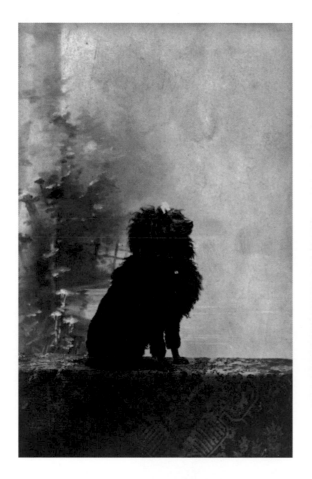 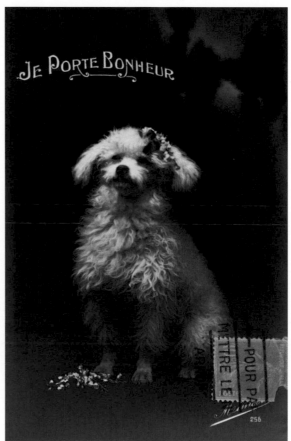

LEFT: Photographer unknown, *Untitled*, France, c. 1900

RIGHT: Photographer unknown, *Je Porte Bonheur*, France, c. 1900

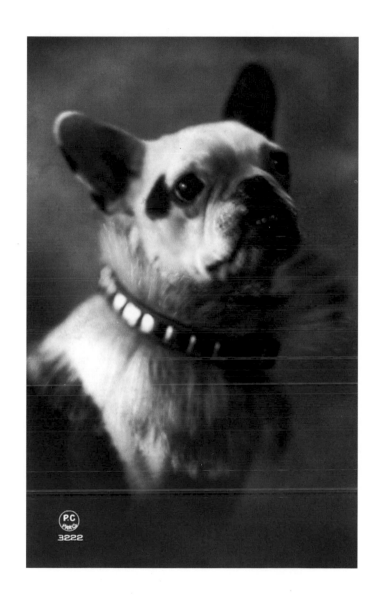

Photographer unknown, *French Bulldog*, Paris, c. 1910

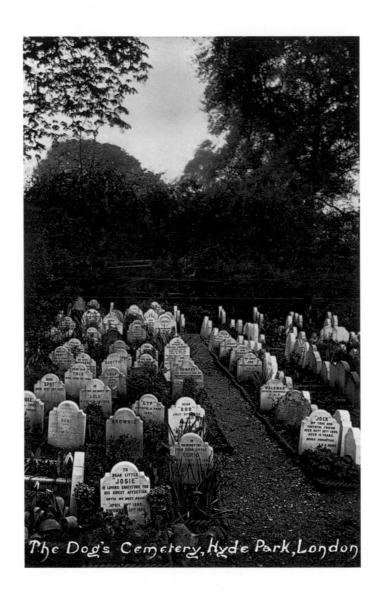

Photographer unknown, *The Dog's Cemetery*, Hyde Park, London, c. 1910

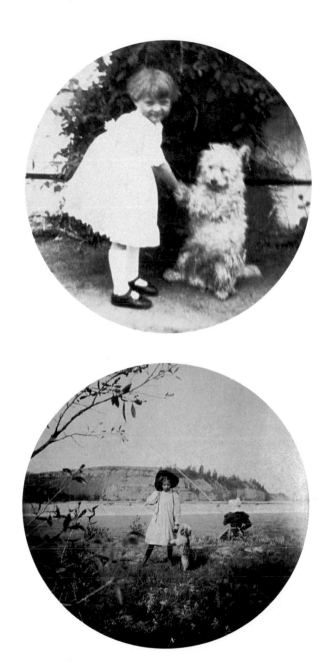

TOP: Photographer unknown, *"G'morning, Jes Fine, How do you do?"* c. 1900

BOTTOM: Photographer unknown, *Girl in a Hat*, c. 1900

Photographer unknown, *Untitled*, France, c. 1910

Photographer unknown, *Untitled*, USA, c. 1910

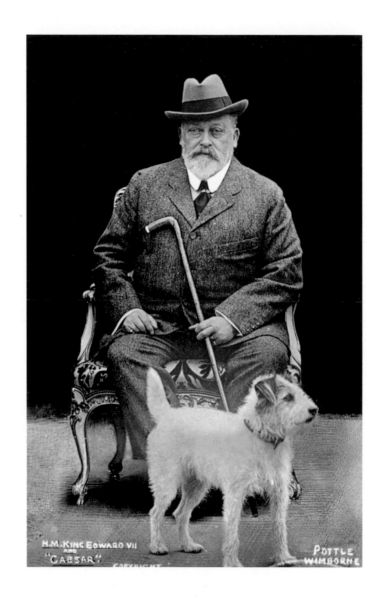

Pottle Studio, *H.M. King Edward VII and Caesar*, Wimborne, England, c. 1908

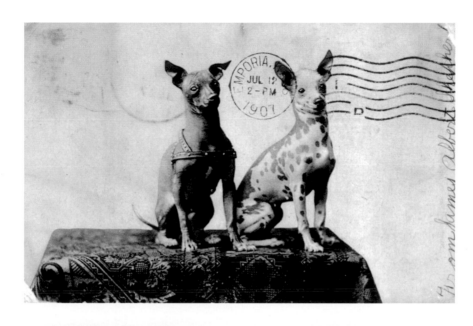

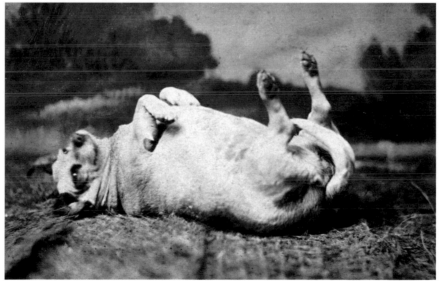

TOP: Theo. Stroefer, *Untitled*, Germany, 1907

BOTTOM: Inv. D. Frederic, *Fat Little Dog on Its Back*, Waynesboro, Pennsylvania, c. 1910

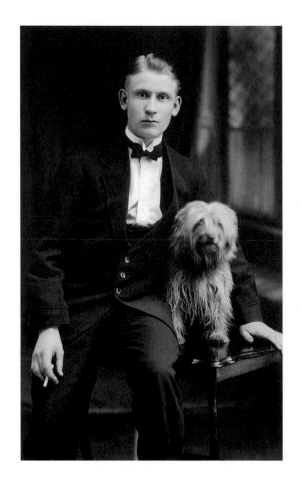 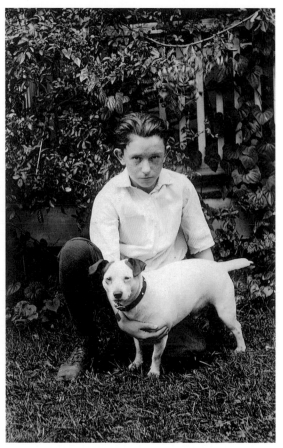

LEFT: Studio of Horace Dudley, *Untitled*, England, 1920s

RIGHT: Photographer unknown, *Untitled*, USA, 1920s

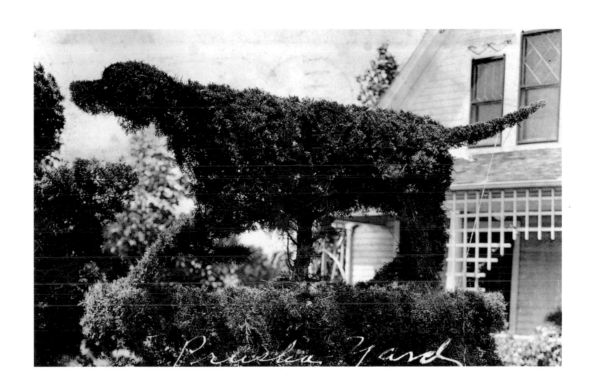

Photographer unknown, *Untitled*, Crete, Nebraska, 1929

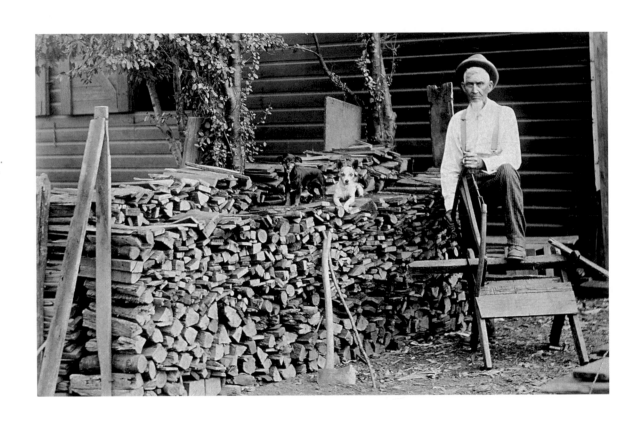

Photographer unknown, *Untitled*, c. 1905

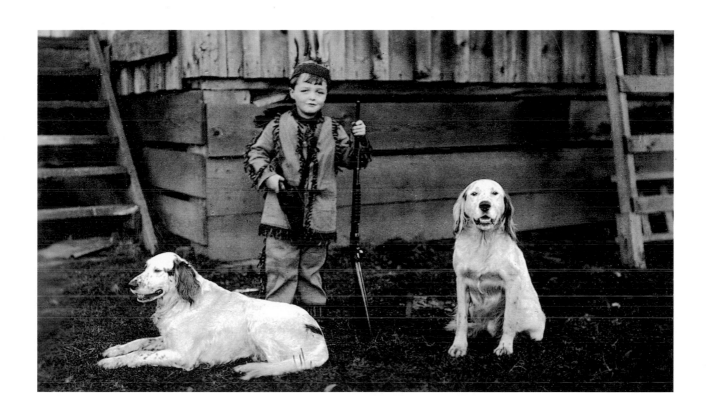

Photographer unknown, *Untitled*, c. 1925

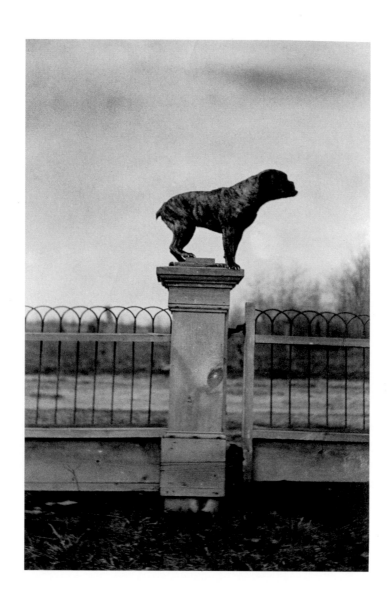

Photographer unknown, *On Picket Duty*, USA, c. 1920

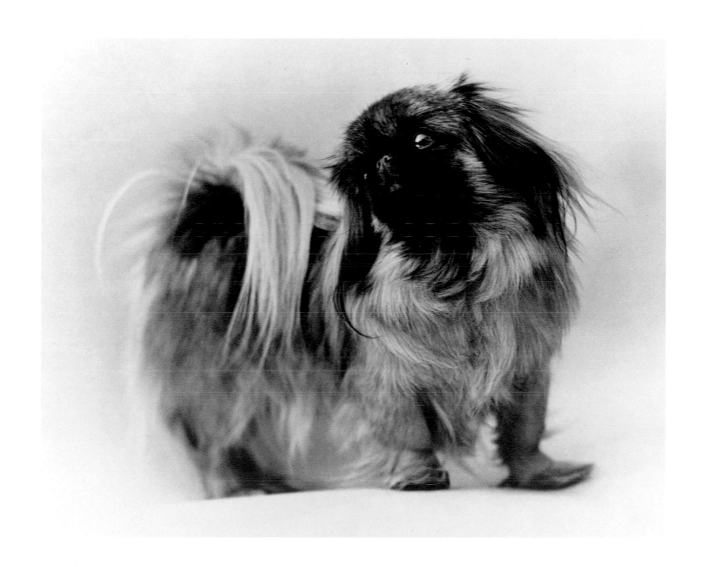

Edward Weston, *Untitled*, c. 1926

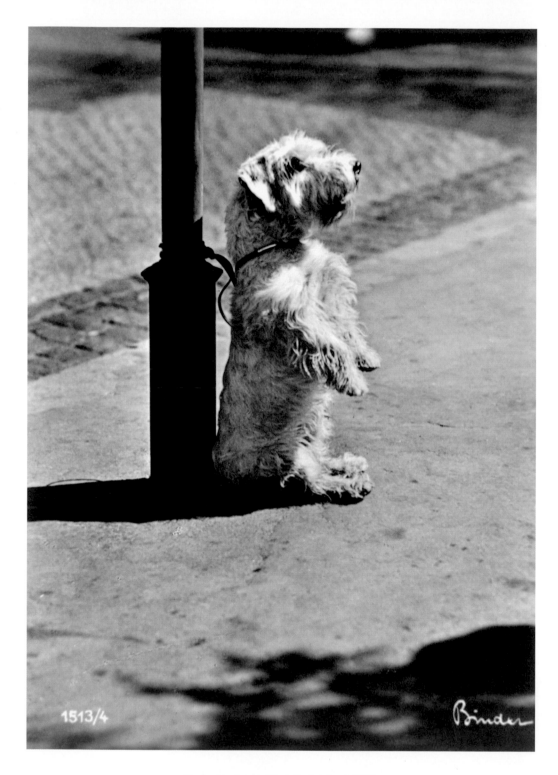

Binder Studio, *Untitled*, Switzerland, 1938

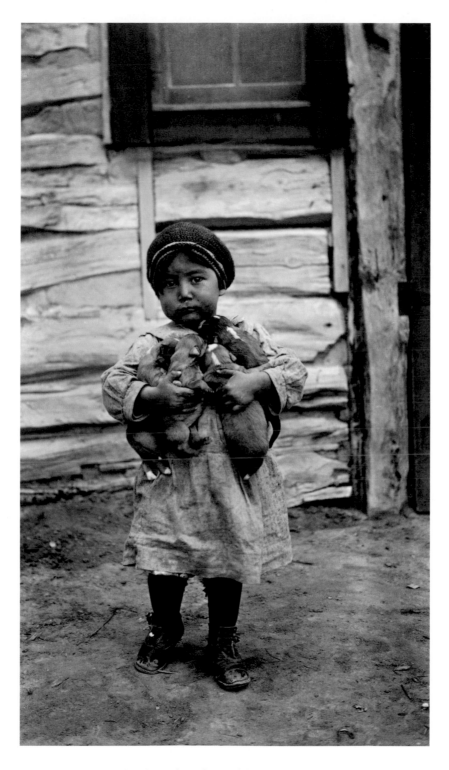

Eugene Buechel, *Martha May Fish with an Armful of Pets*, from the portfolio of the Rosebud and Pine Ridge Photographs, March 22, 1931

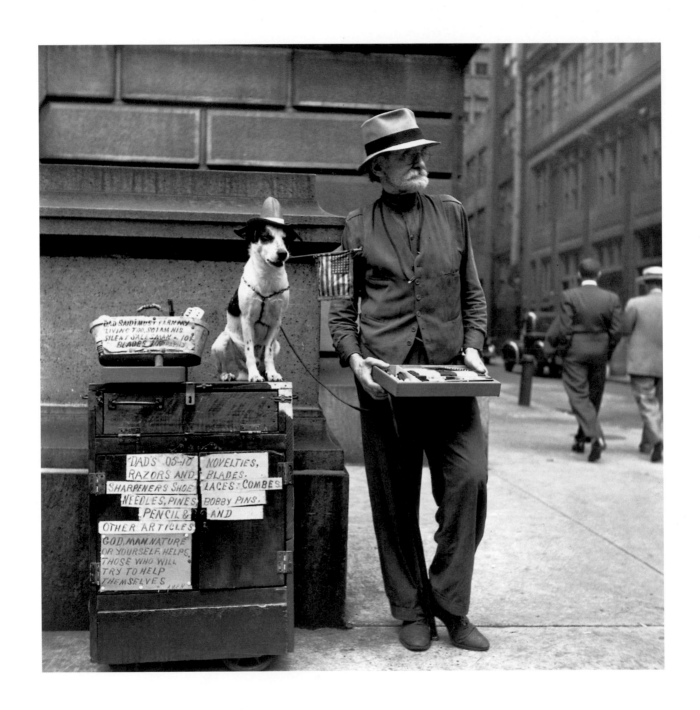

Louis Faurer, *Silent Salesman*, Philadelphia, Pennsylvania, c. 1937

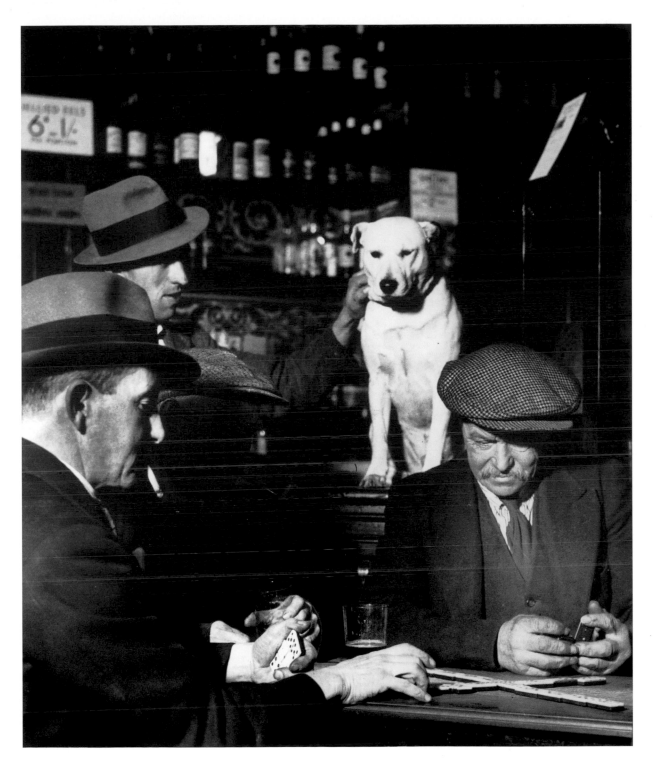

Bill Brandt, *Domino Players*, North London, c. 1931–36

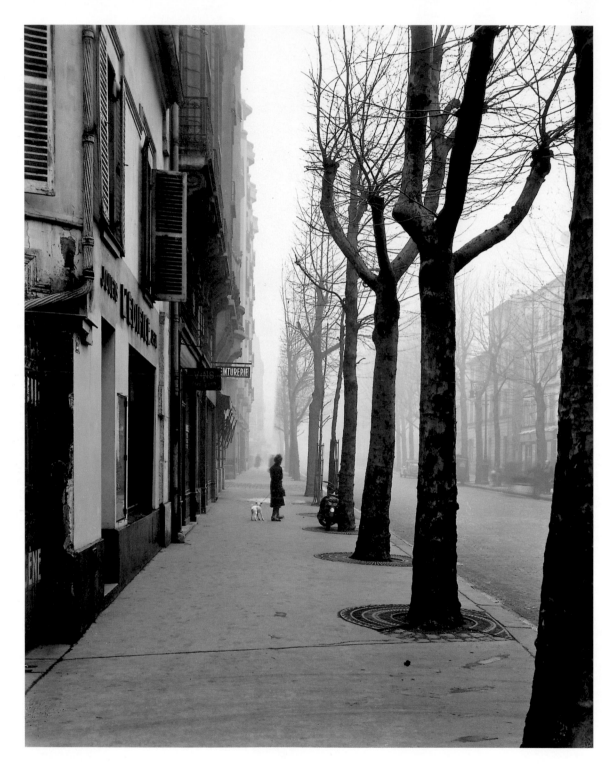

Louis Stettner, *Avenue de Chatillon*, Paris, 1950

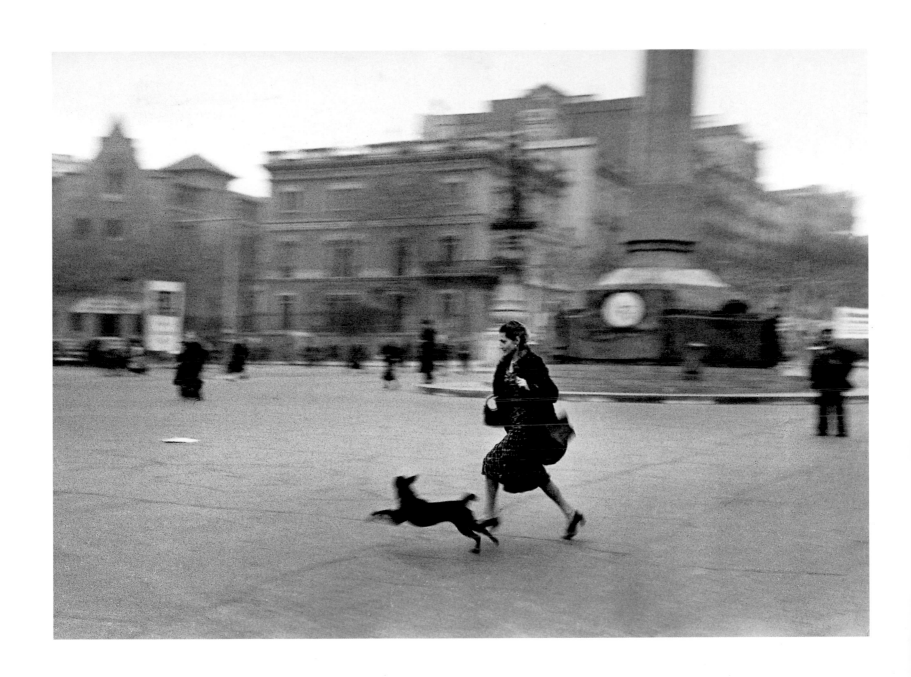

Robert Capa, *Air-raid*, Barcelona, 1939

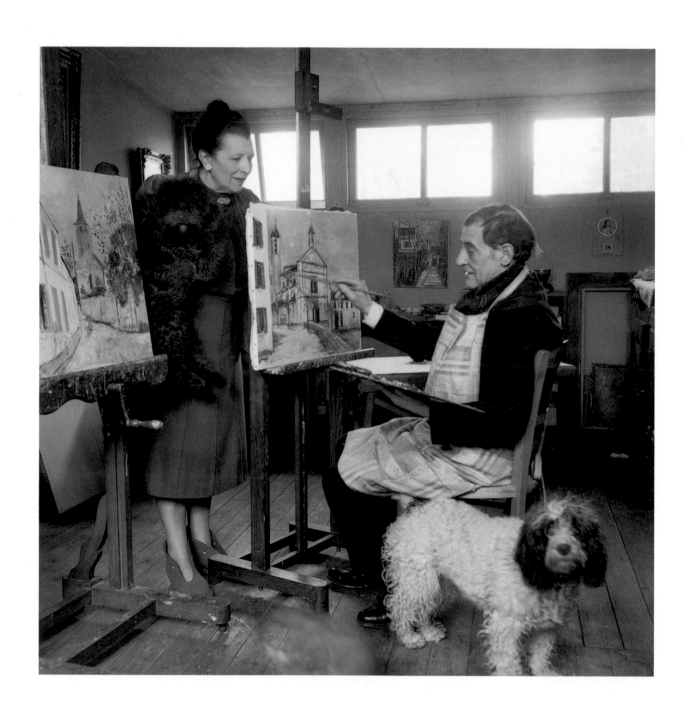

Jean and Louis-Albert Seeberger, *Maurice Utrillo*, France, c. 1940

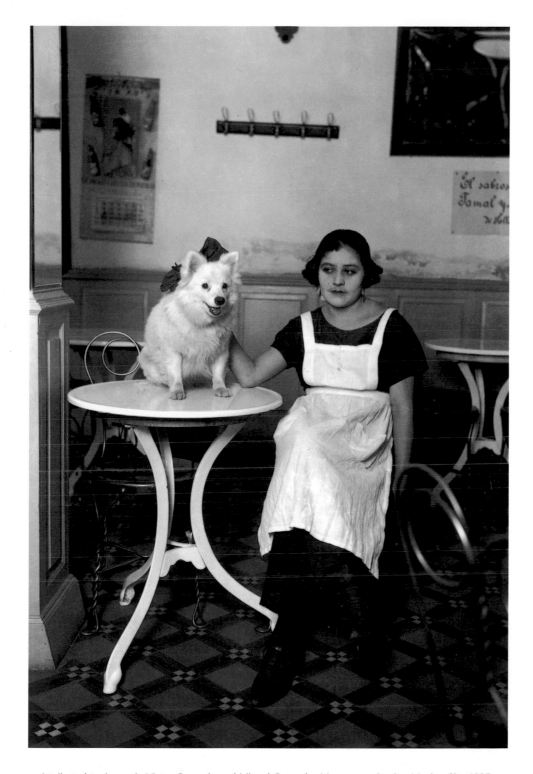

Attributed to Augustin Victor Casasola and Miguel Casasola, *Mesera con Perrito*, Mexico City, 1935

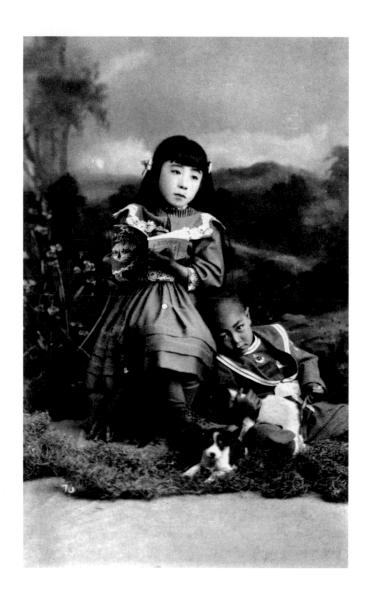

Photographer unknown, *Untitled*, Japan, c. 1940

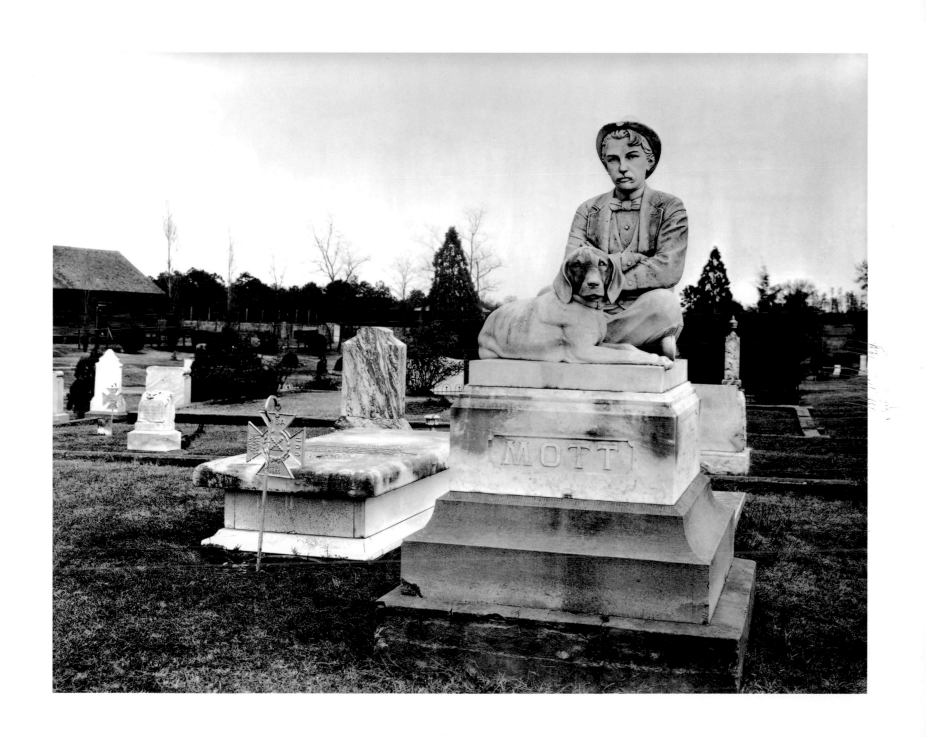

Walker Evans, *Victorian Gravestone*, Mississippi, December 1935

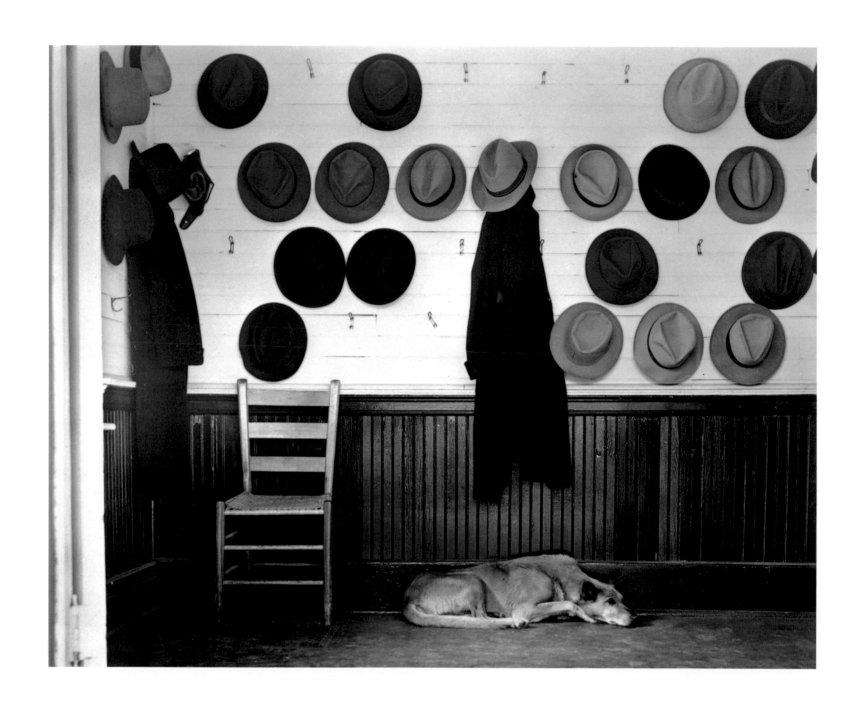

John Vachon, *Methodist Church Vestibule*, Gadsden, Alabama, December 1940

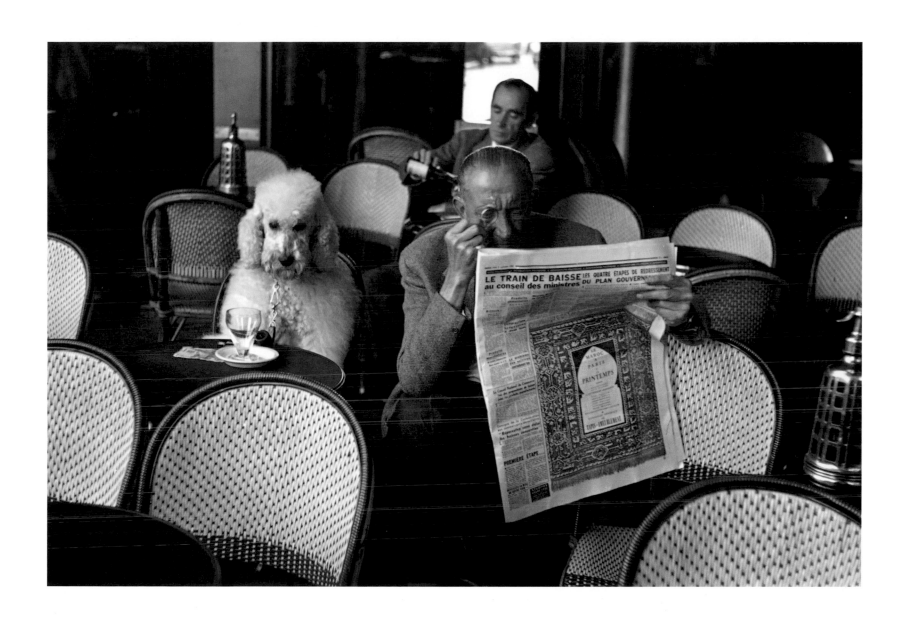

Edouard Boubat, *On the Terrace of the Deux Magots*, Saint-Germain-des-Prés, Paris, 1955

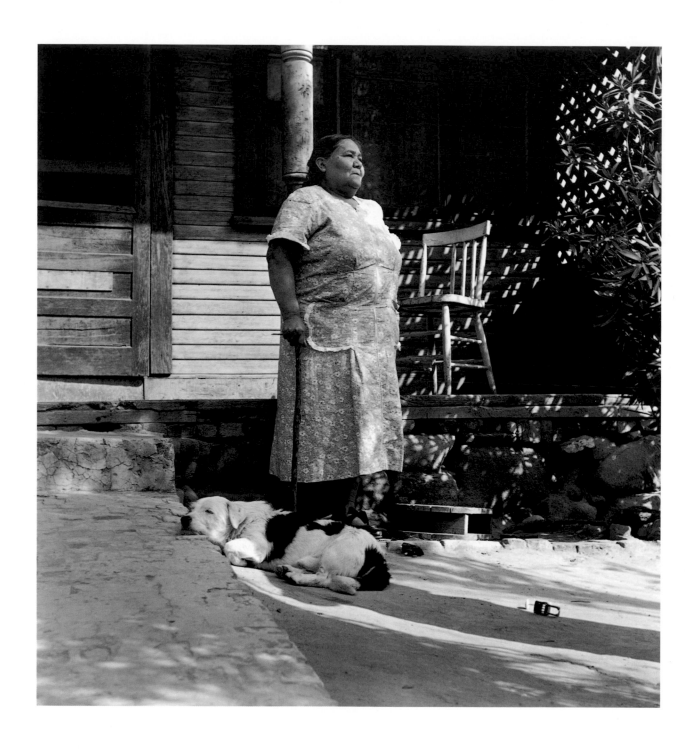

Don Normark, *Francisca Bantacorte and Her Husband's Dog*, La Loma, Chavez Ravine, Los Angeles, 1949

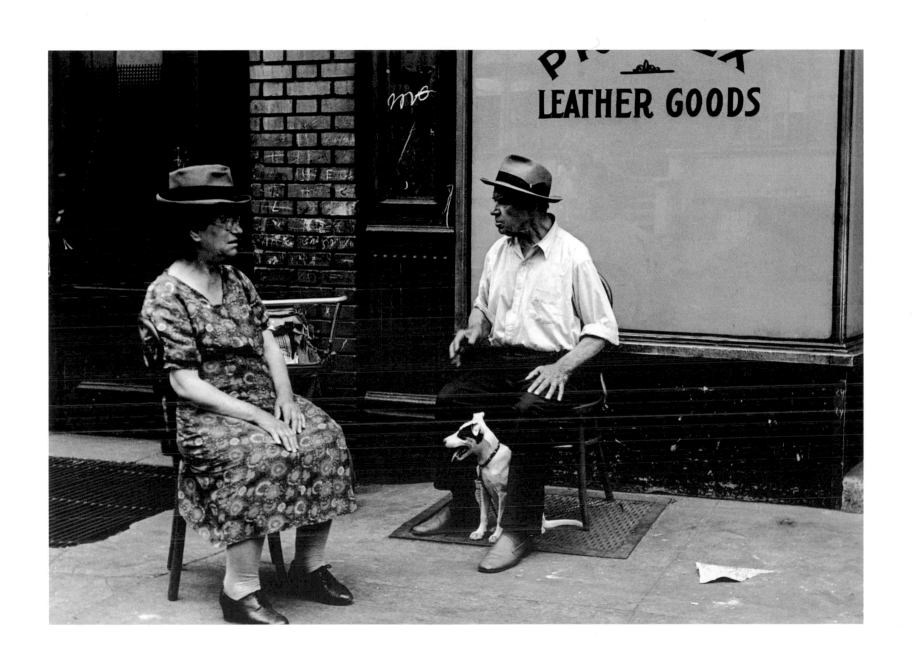

Helen Levitt, *New York City*, 1940

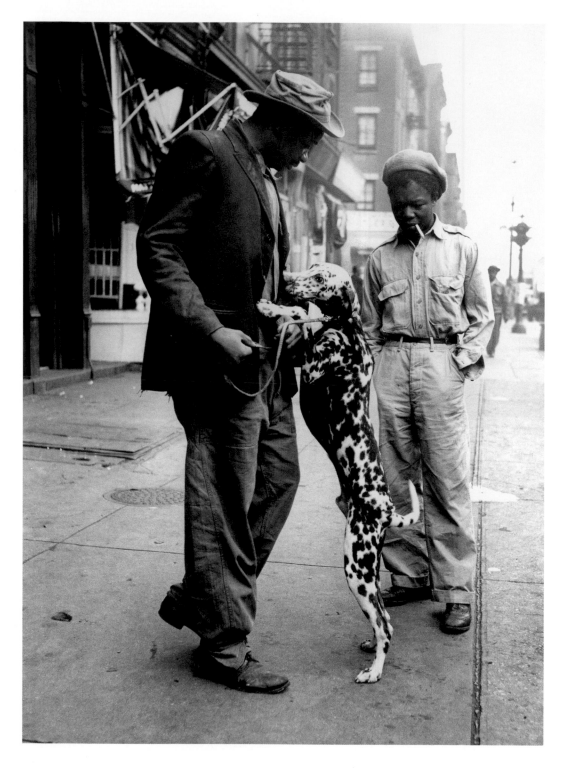

Richard Avedon, *Harlem*, New York, March 23, 1949

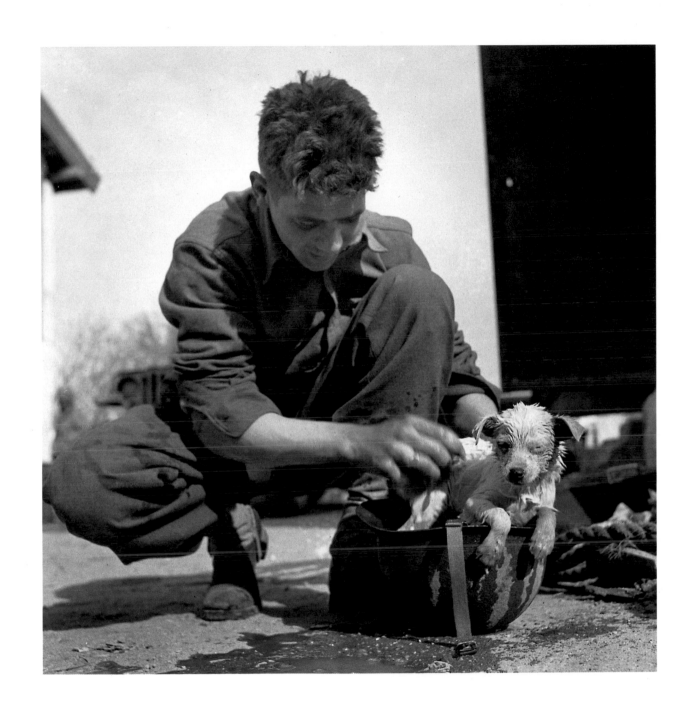

Robert Capa, *Rome*, 1943

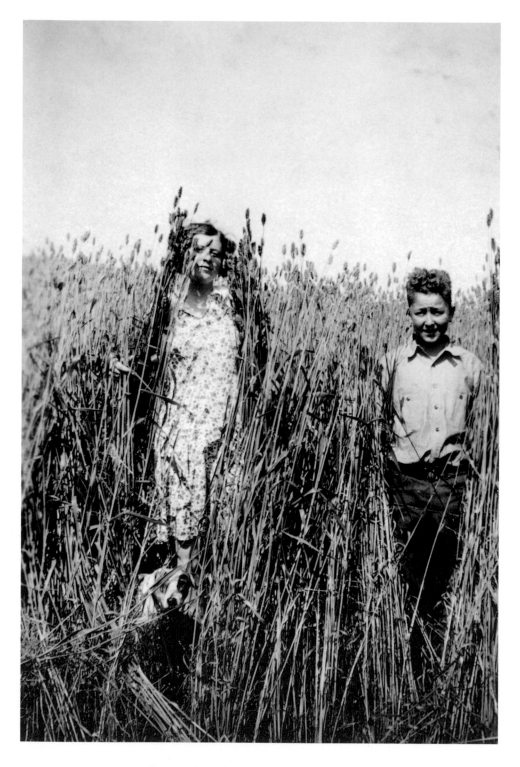

Photographer unknown, *Untitled*, USA, c. 1940

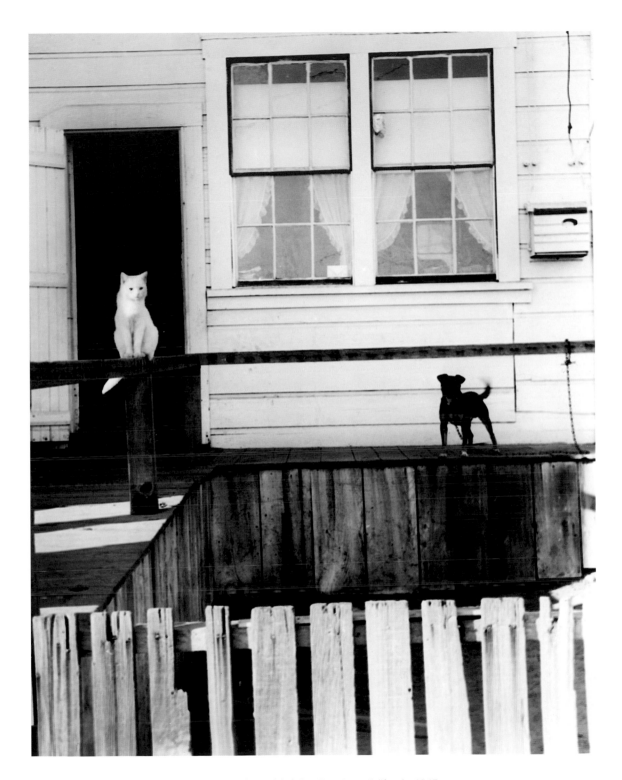

William Heick, *Untitled*, San Francisco, California, 1947

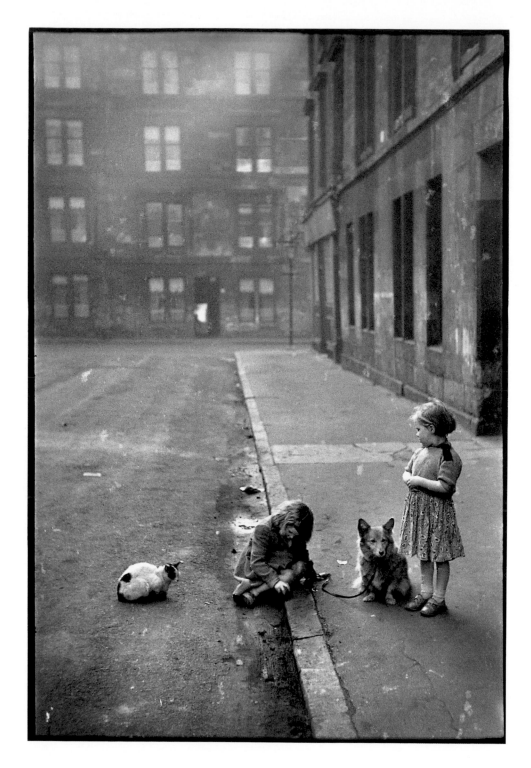

Jacques Lowe, *Glasgow*, 1953

44

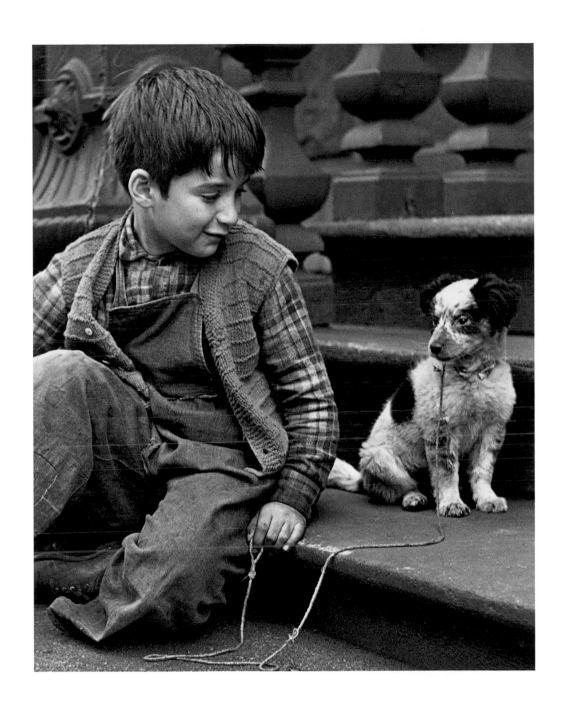

Clemens Kalischer, *West Side*, New York, 1950s, from *The Family of Man*

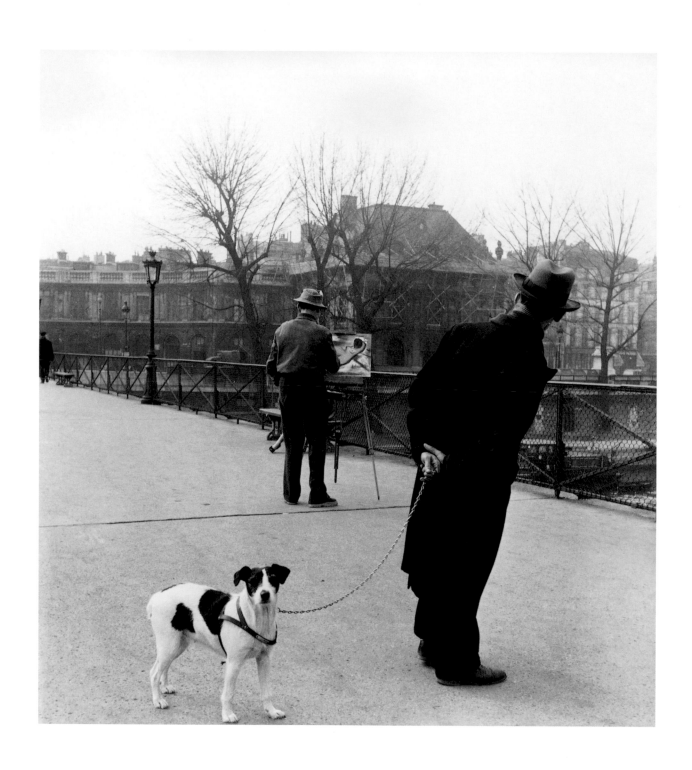

Robert Doisneau, *Le Chien du Pont des Arts*, Paris, 1953

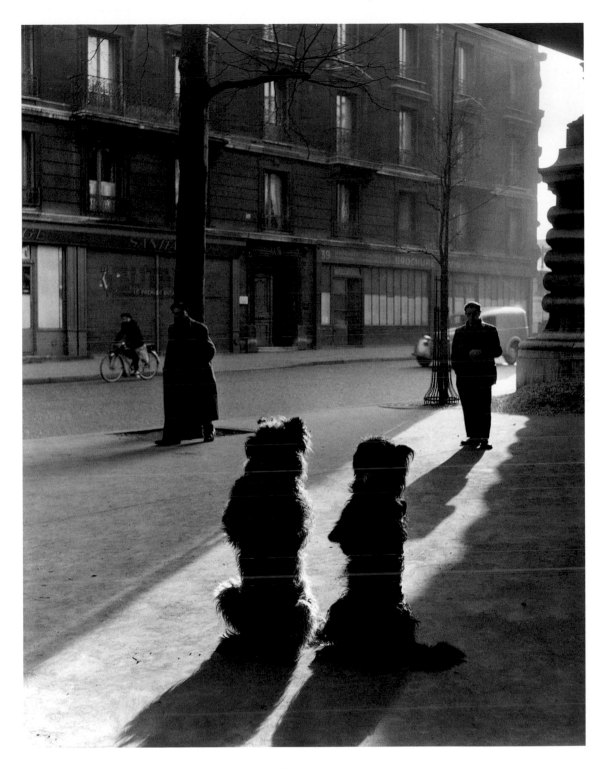

Robert Doisneau, *Les Chiens du Metro de La Chapelle*, Paris, 1956

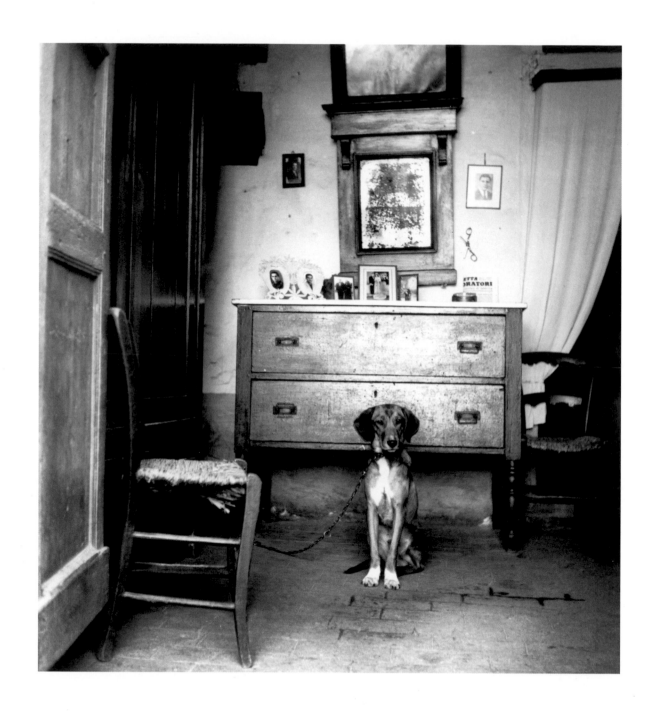

Werner Bischof, *Inglesias*, Sardinia, 1950

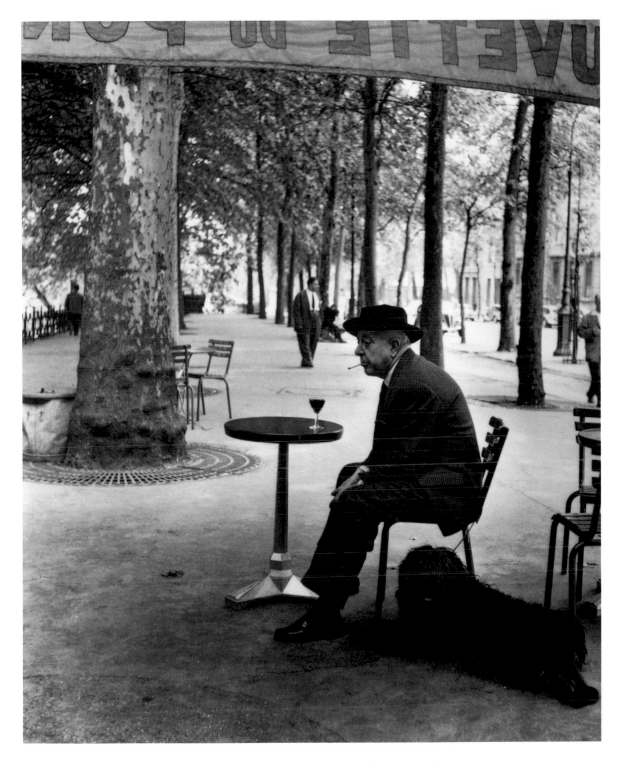

Robert Doisneau, *Jacques Prévert au Guéridon*, Paris, 1955

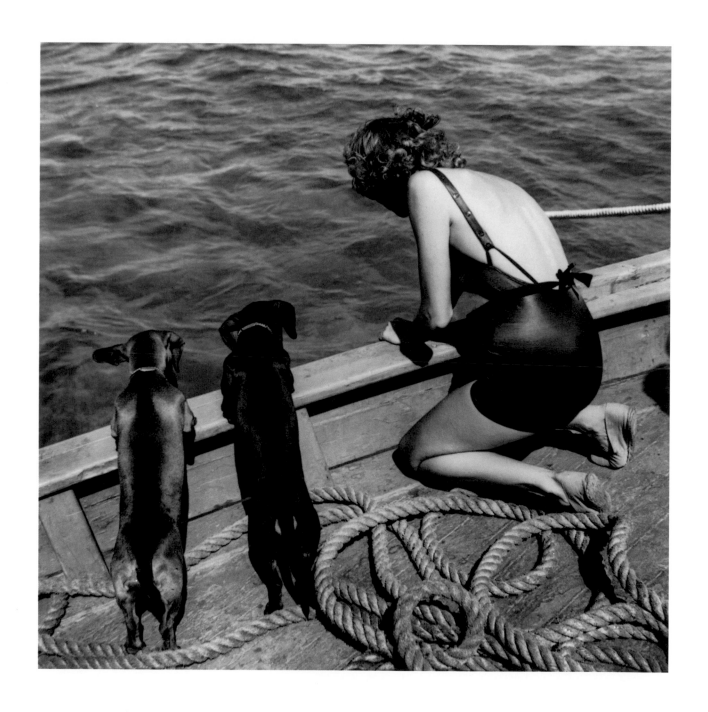

Toni Frissell, *Woman with Two Dachshunds*, Florida, 1939

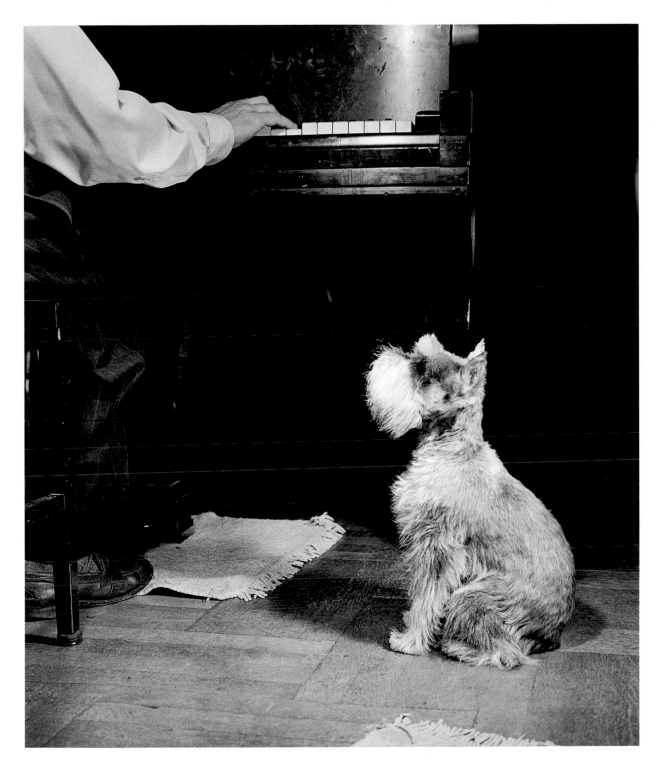

Ilse Bing, *"Staccato" Listening to Beethoven*, New York, 1955

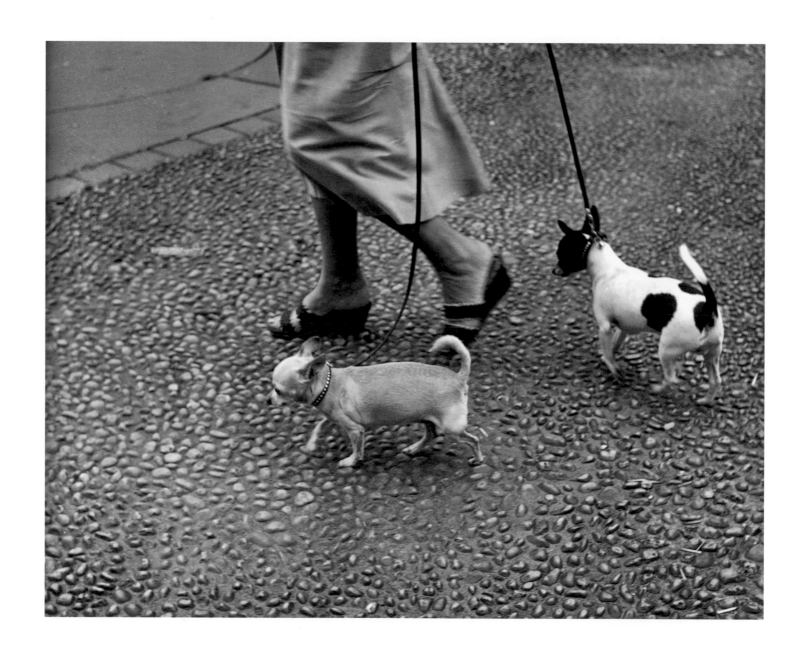

Clemens Kalischer, *Dogs and Pebbles*, Plaza Hotel, New York, 1950s

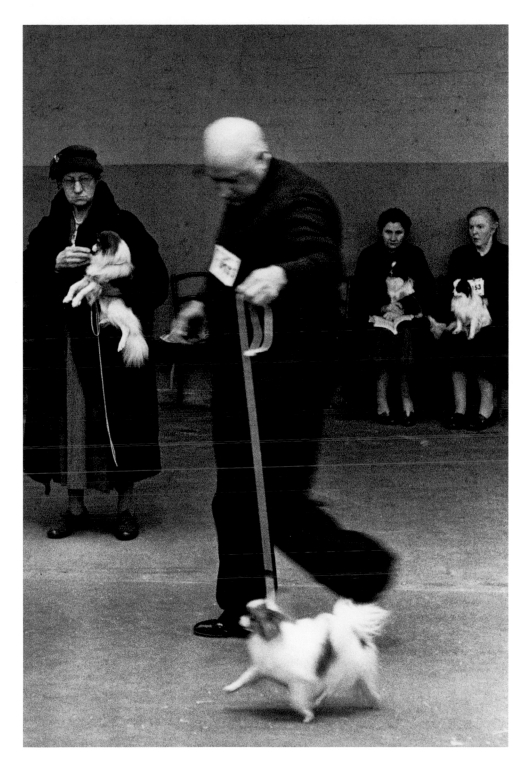

Snowdon, *Crufts Dog Show at Olympia*, London, 1958

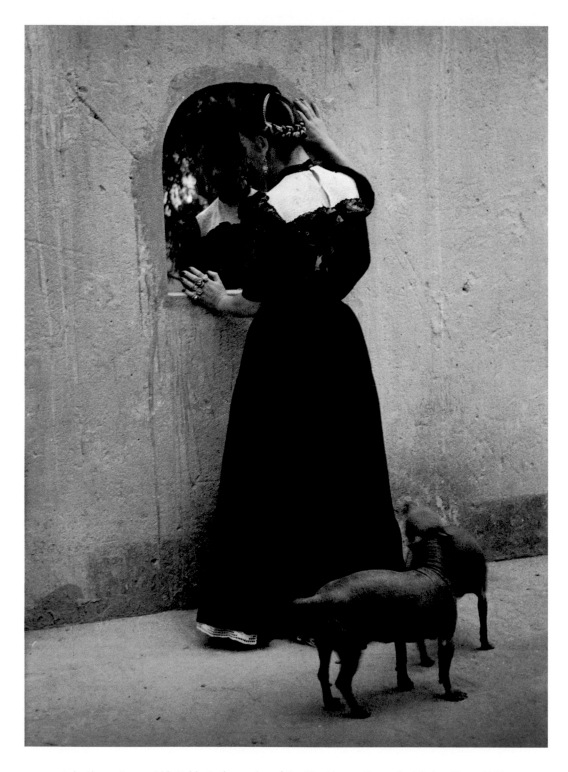

Lola Alvarez Bravo, *Frida Kahlo*, In the garden of the Blue House, Coyoacán, Mexico City, c. 1952

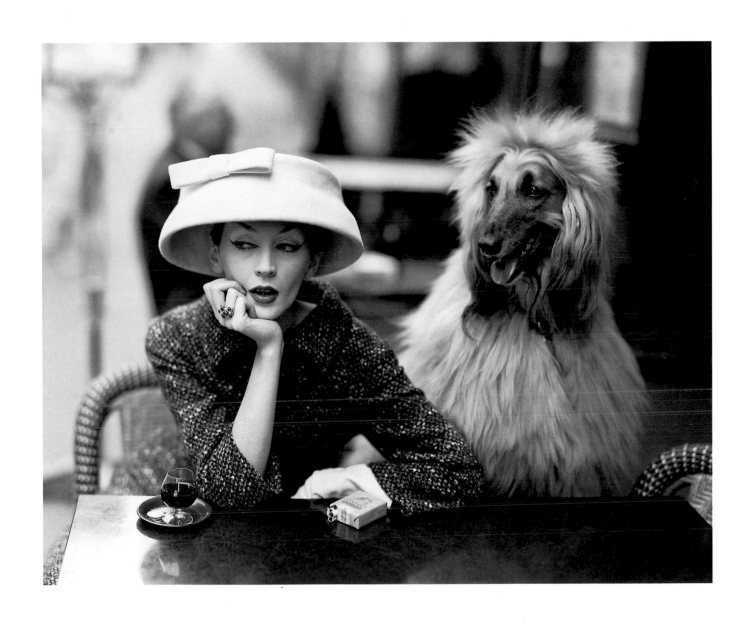

Richard Avedon, *Dovima with Sacha, Cloche by Balenciaga*, Café des Deux Magots, Paris, August 1955

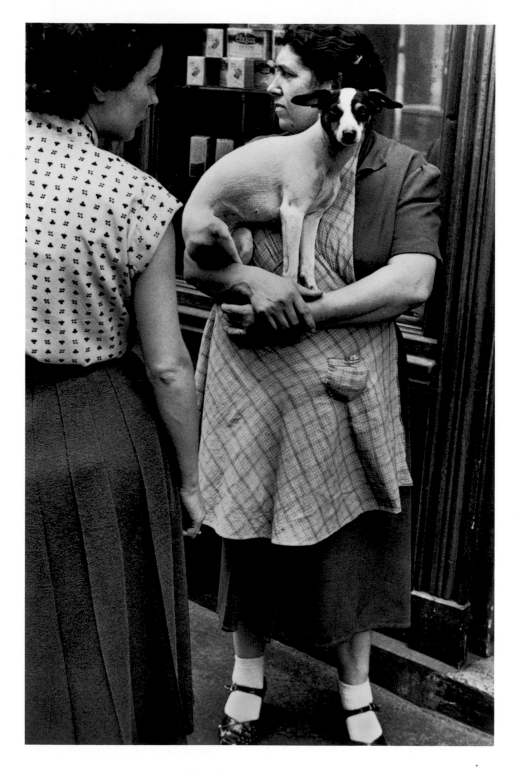

Elliott Erwitt, *Paris*, France, 1952

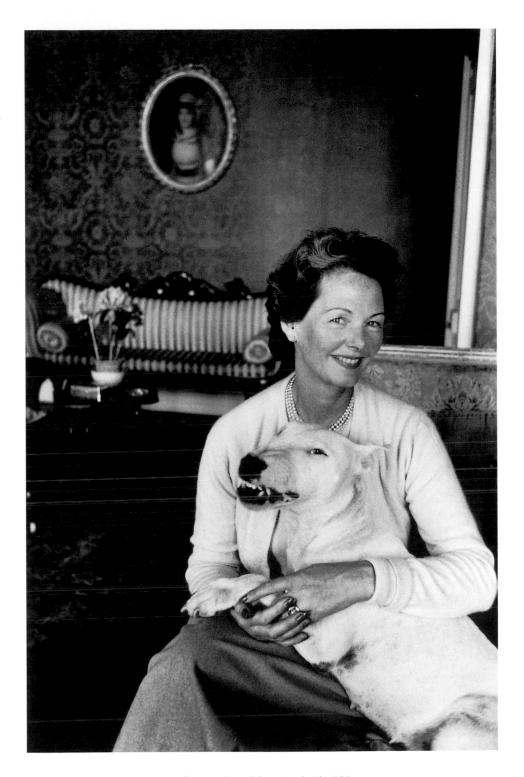

Elliott Erwitt, *Brighton*, England, 1956

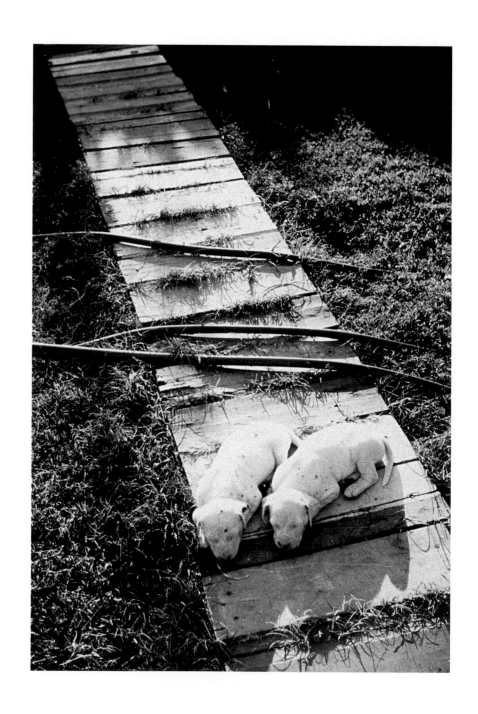

Photographer unknown, *Untitled*, USA, August 1965

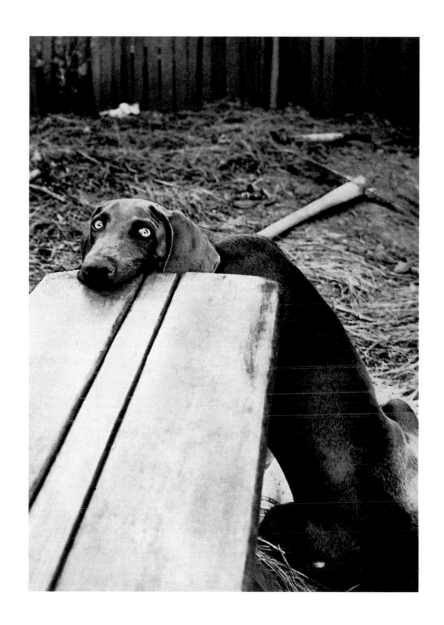

Henri de Chatillon, *Le braque de Weimar*, 1956

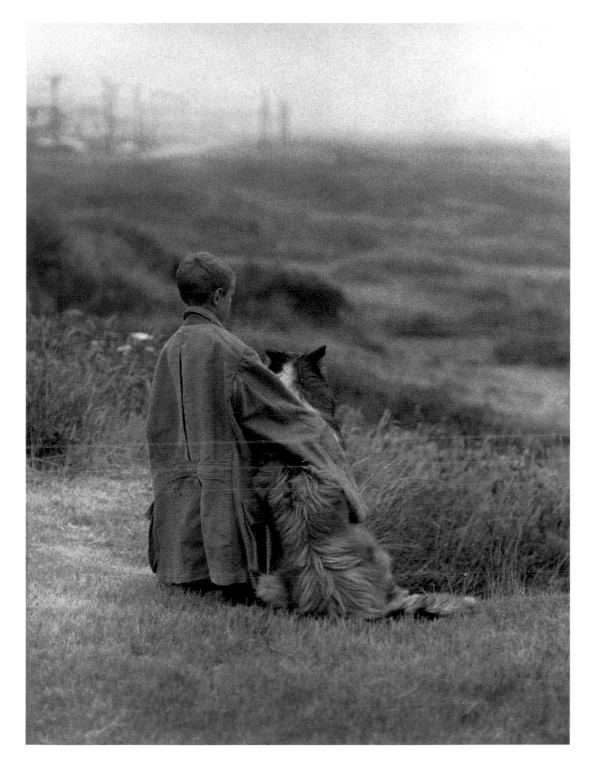

Kathryn Abbe, *At Hither Hills*, Montauk, Long Island, 1957

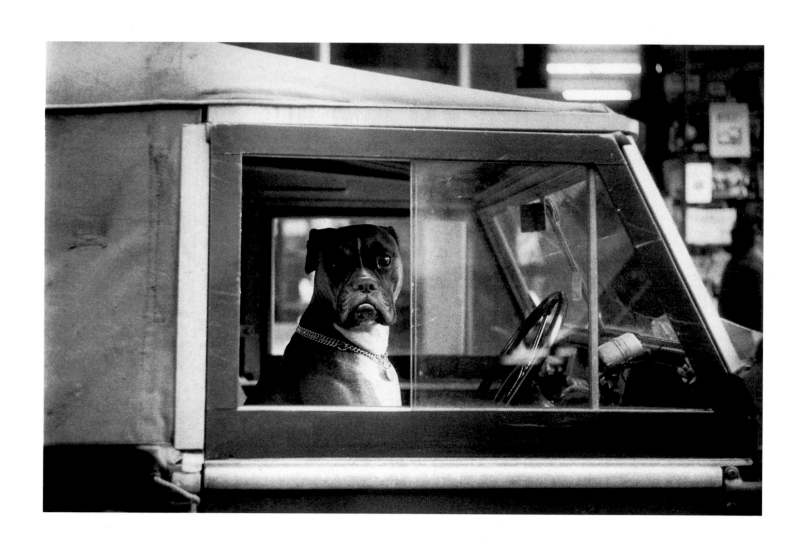

Bruce Davidson, *Dog Sitting in the Front Seat of a Truck*, England, 1964

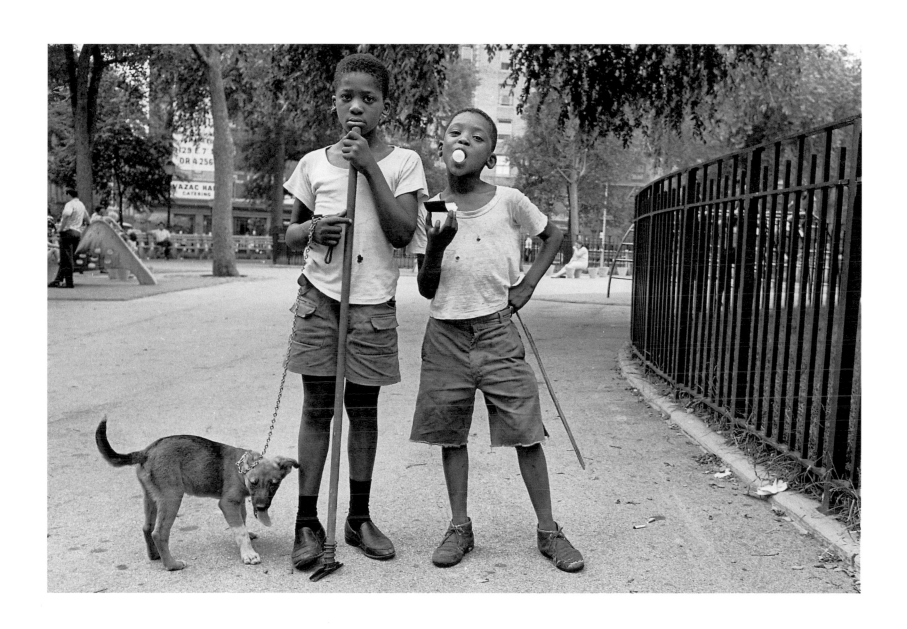

Jill Freedman, *Bubble Gum*, New York, 1967

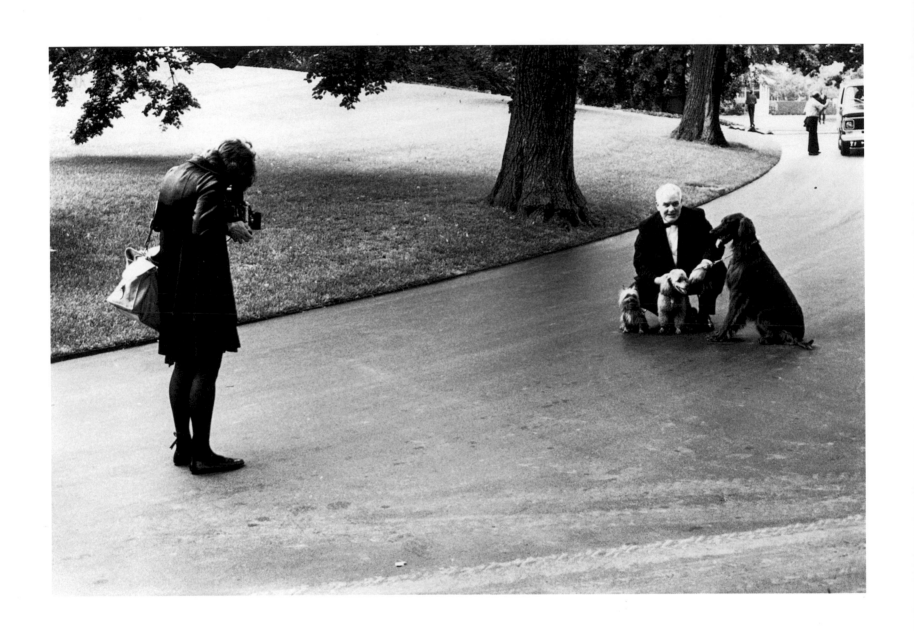

Elliott Erwitt, *Diane Arbus*, Washington, DC, 1971

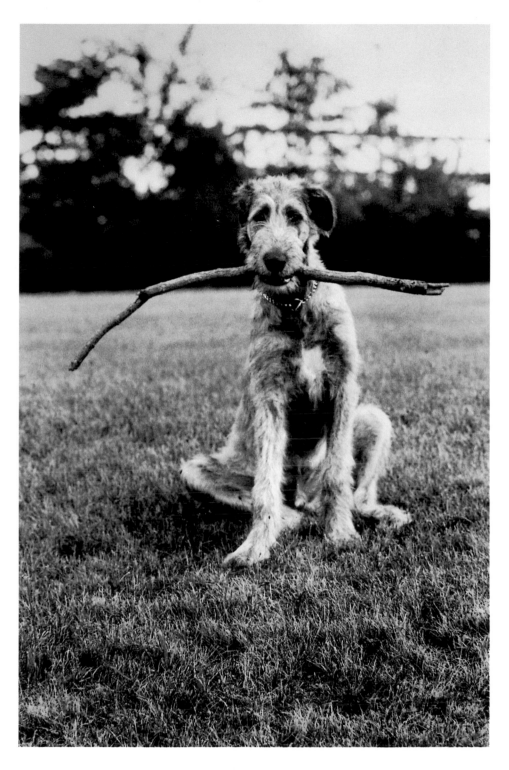

Elliott Erwitt, *New Jersey*, 1971

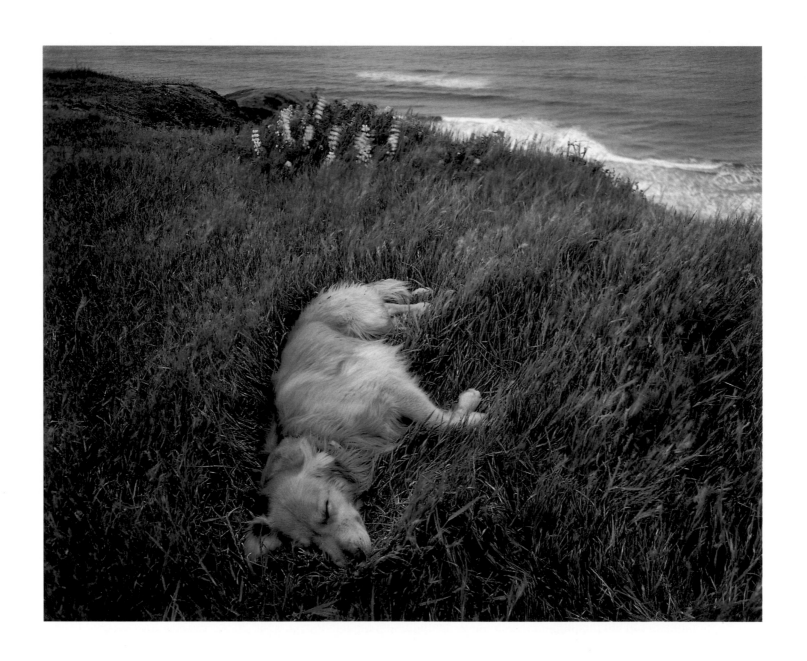

Mark Citret, *Ebby*, San Gregorio, California, 1971

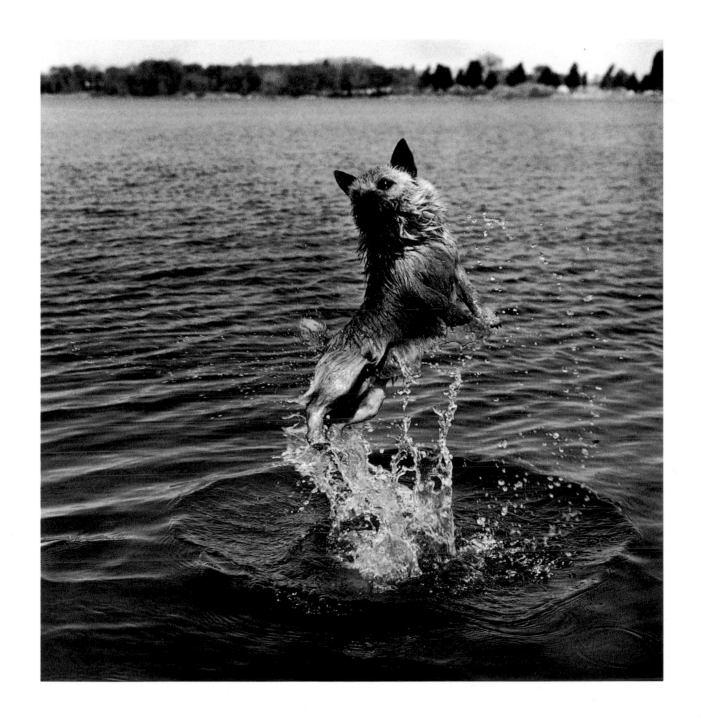

Constance Stuart Larrabee, *Fearless*, Kings Prevention, Chestertown, Maryland, 1977

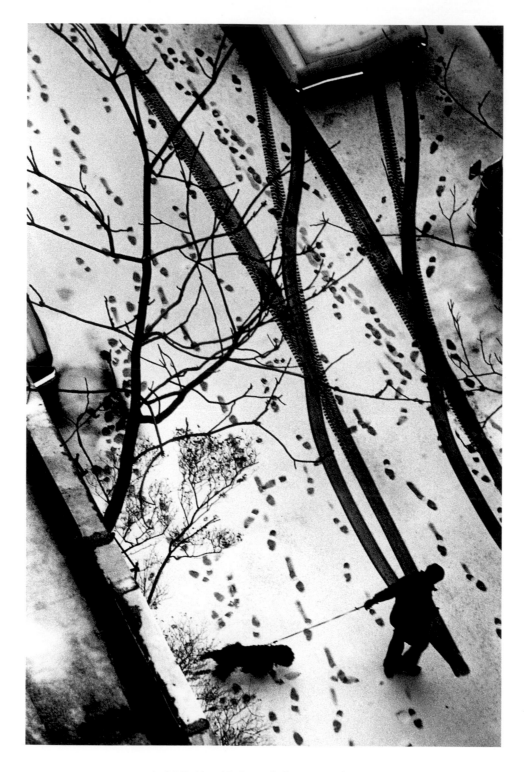

André Kertész, *MacDougal Alley*, New York, 1977

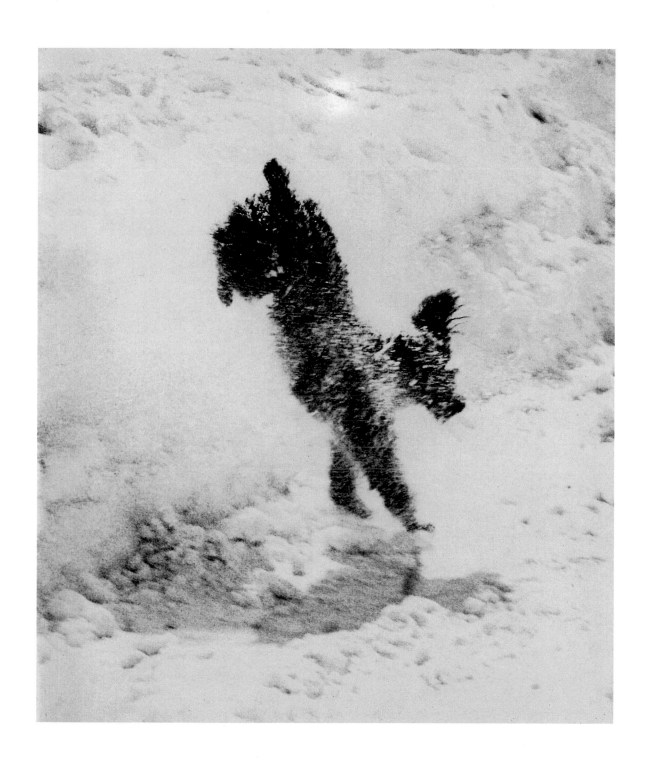

Paul Himmel, *French Poodle*, New York, c. 1955

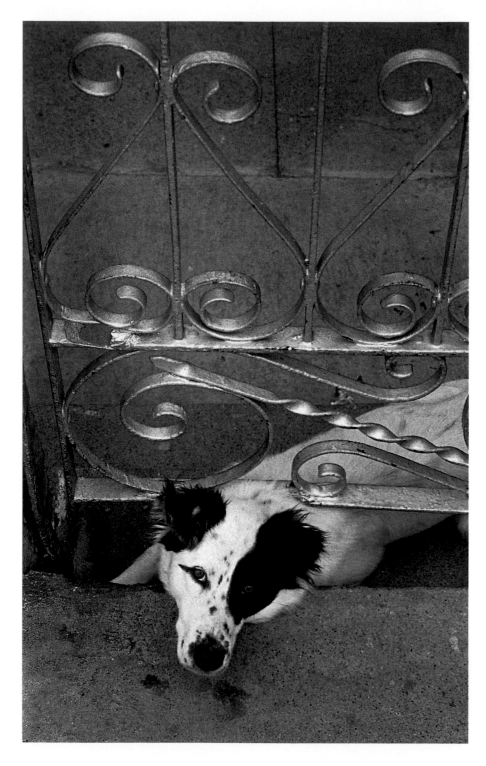

Don Normark, *Street Dog Want-to-Be*, San Francisco, California, 1972

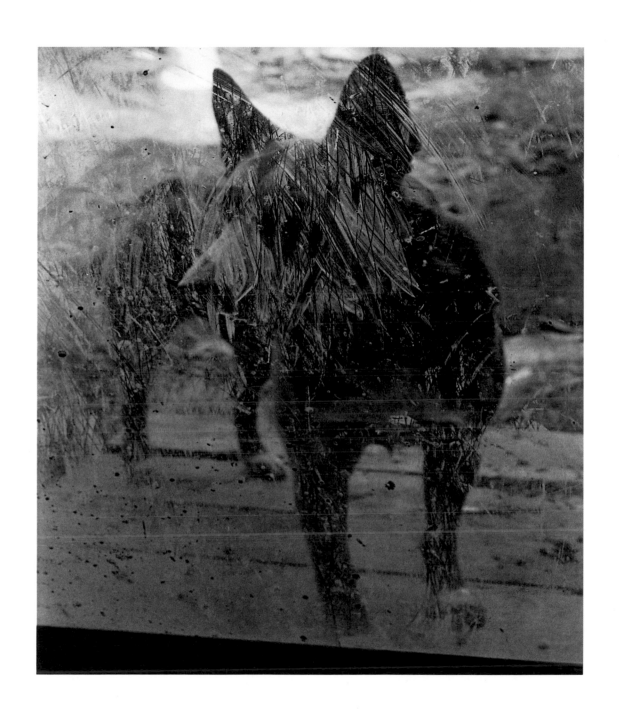

Don Normark, *Roy De Forest's Dog at the Back Door*, San Francisco, California, 1972

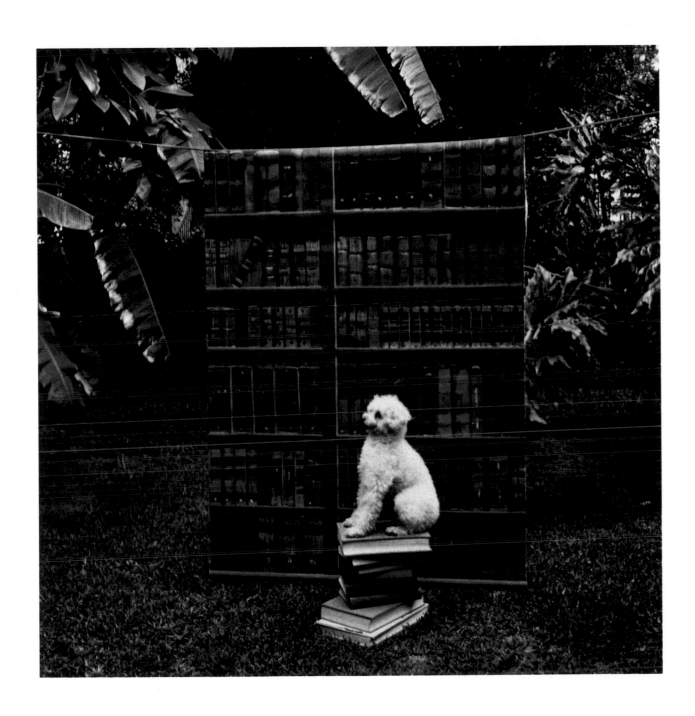

Kenneth Josephson, *Zorba in LA*, California, 1975

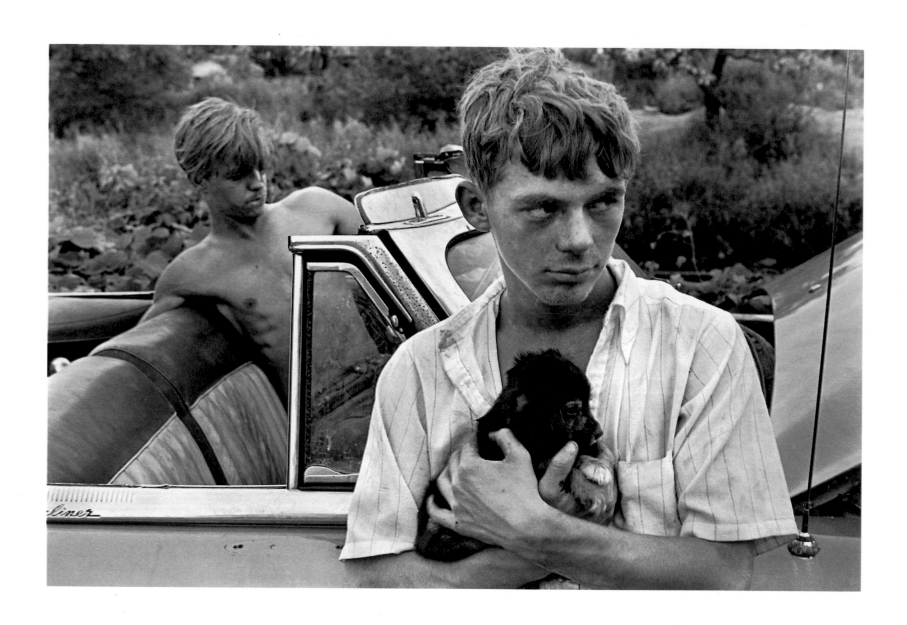

Danny Lyon, *Knoxville*, Tennessee, 1967

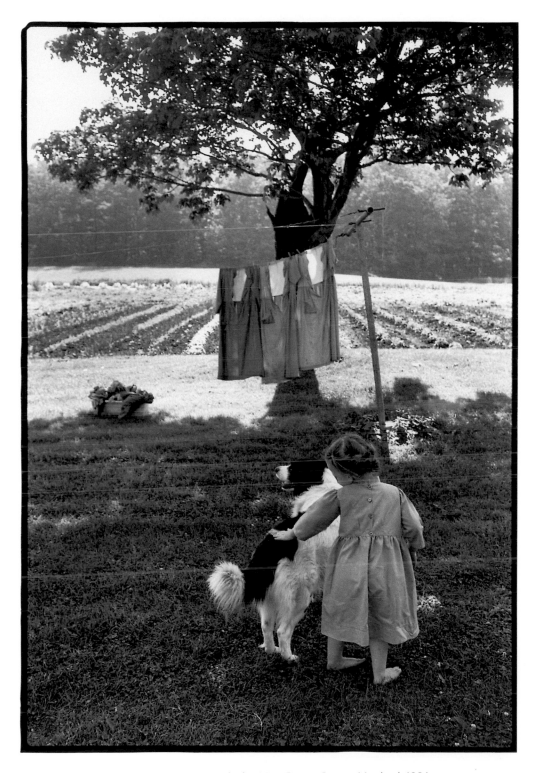

Susie Fitzhugh, *Banjo and Edna Mae*, Garrett County, Maryland, 1984

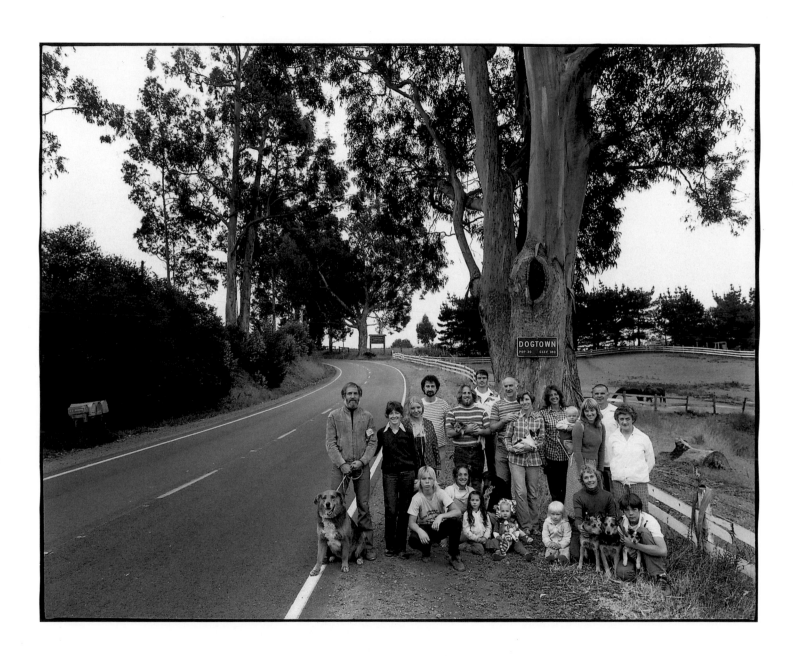

Art Rogers, *Dogtown*, California, 1981

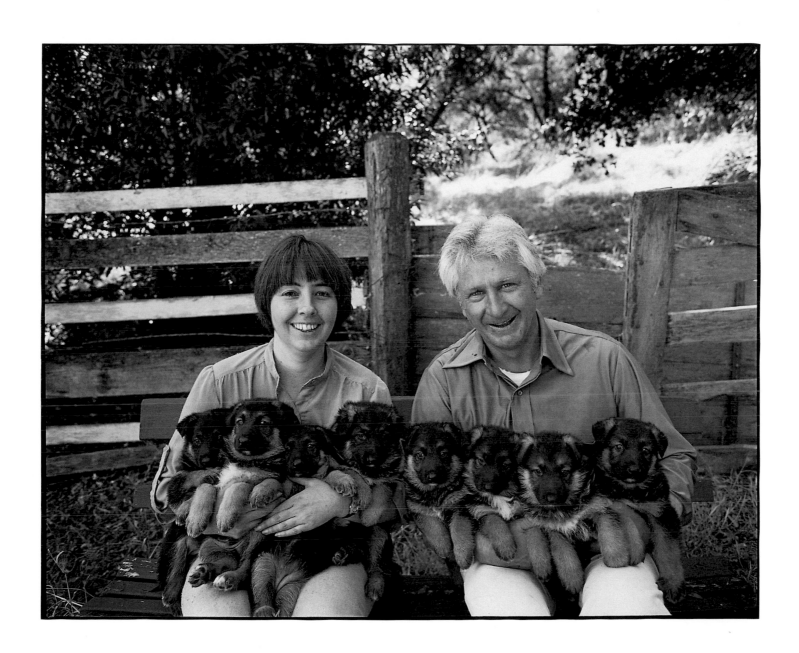

Art Rogers, *Puppies*, San Geronimo, California, 1980

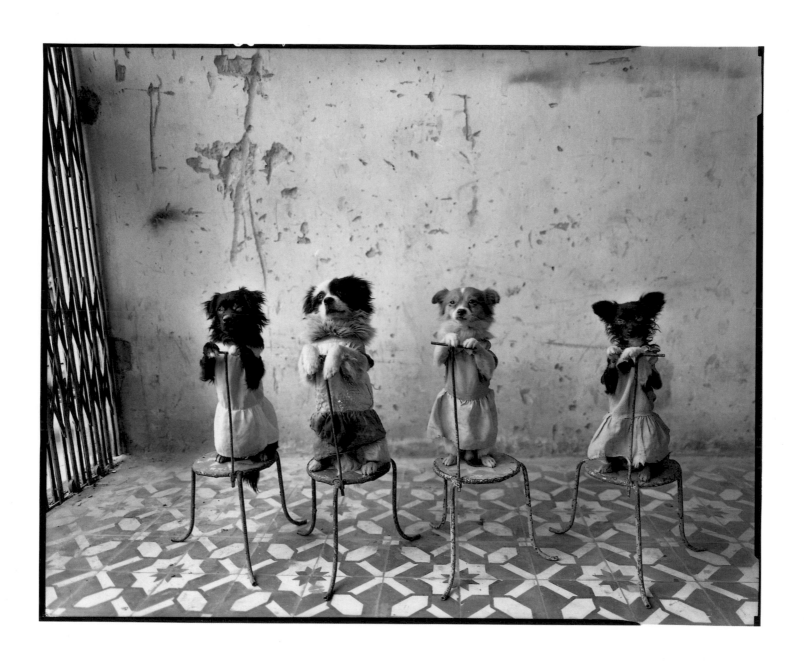

Mary Ellen Mark, *Vietnam Circus Dogs*, Hanoi, 1994

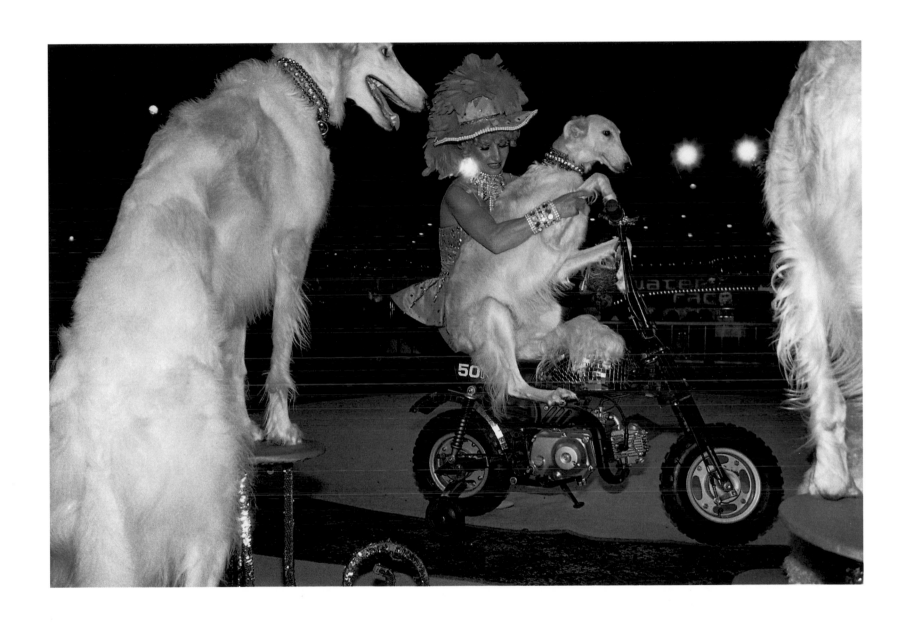

Bill Dane, *Reno, Nevada*, 1983

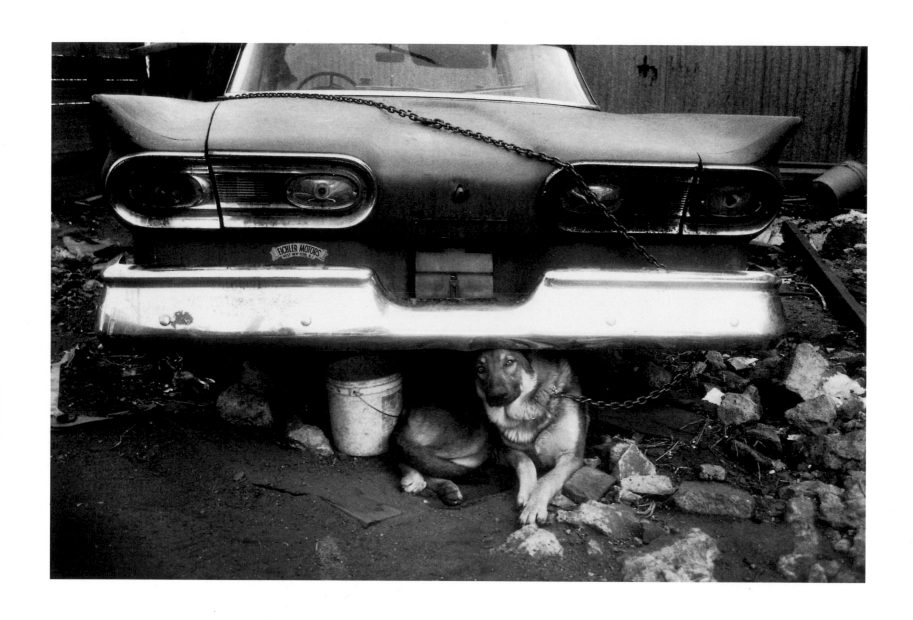

Robin Schwartz, *Chained Dog under Car*, Hoboken, New Jersey, 1984

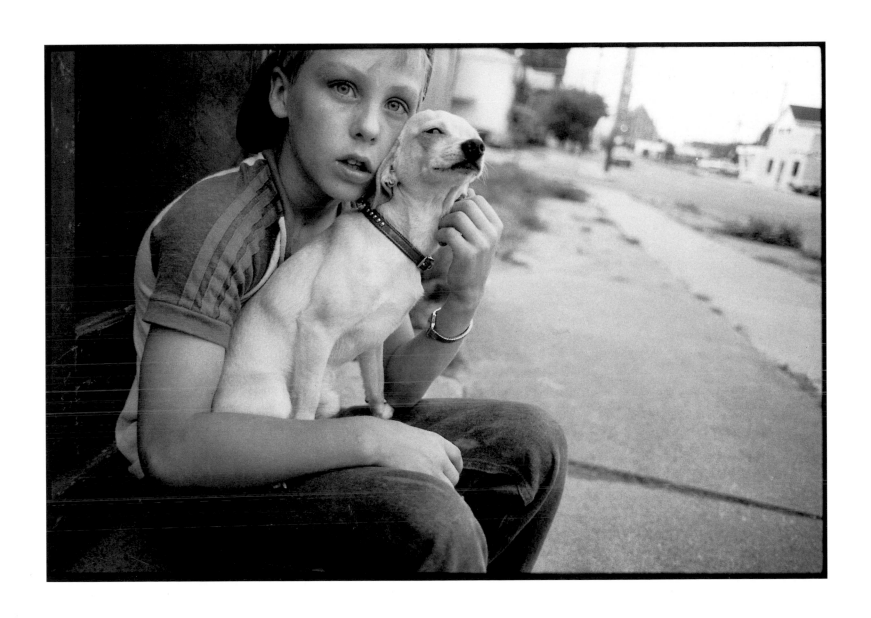

Mary Ellen Mark, *Chuck with His Dog*, Portsmith, Ohio, 1989

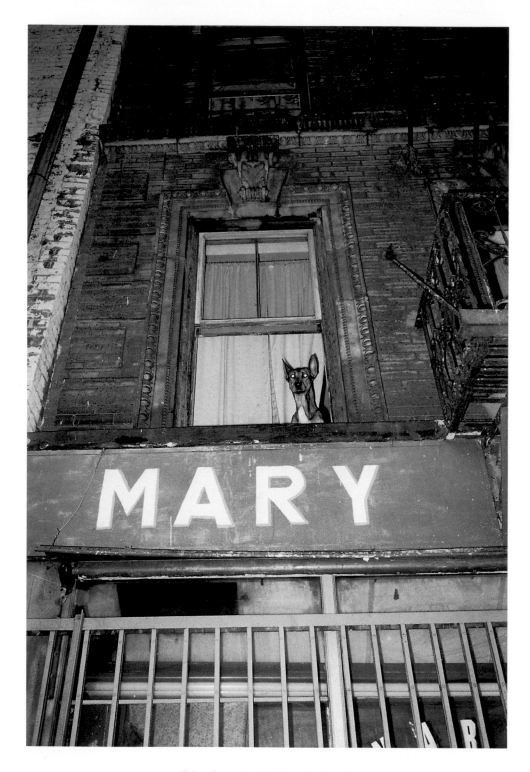

Jill Freedman, *MARY*, New York, 1981

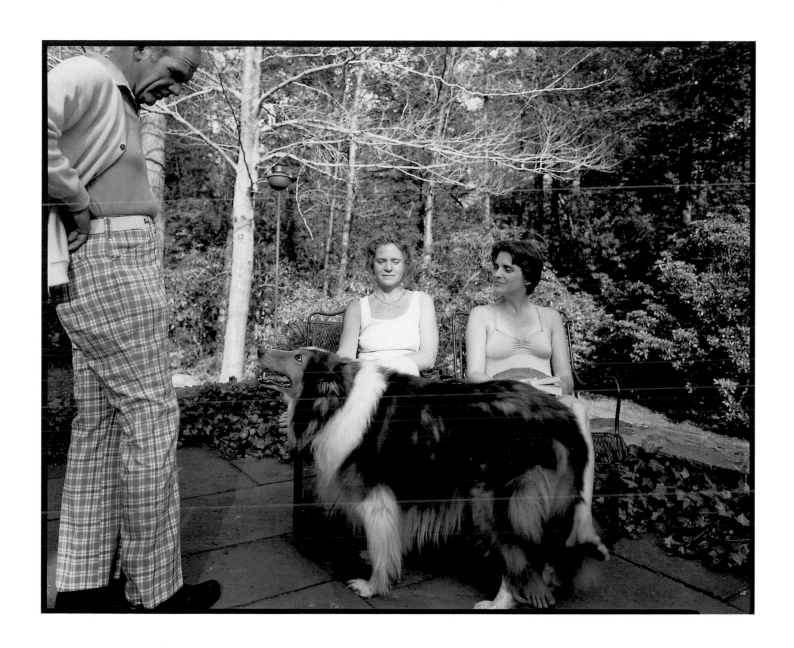

Nicholas Nixon, *New Canaan, Connecticut*, 1980

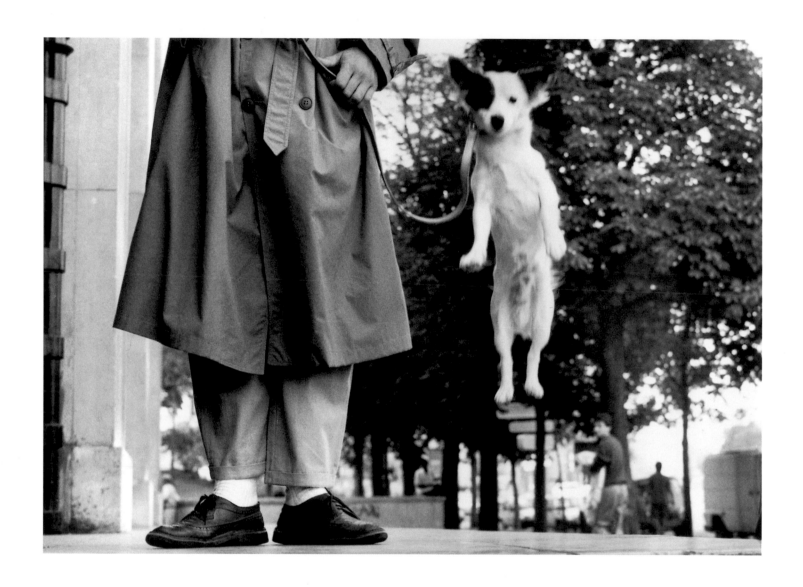

ABOVE: Elliott Erwitt, *Paris*, France, 1989

OPPOSITE: Elliott Erwitt, *Berlin*, Germany, 1995

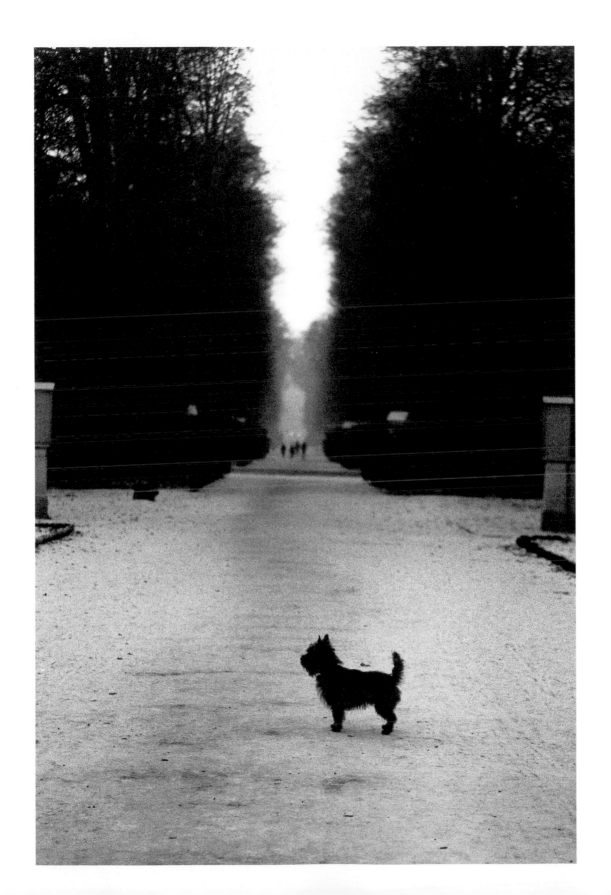

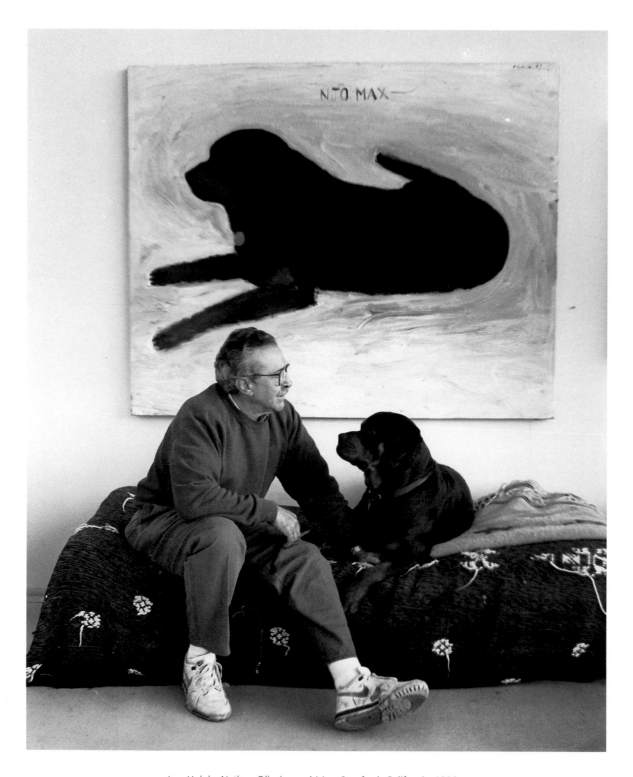

Leo Holub, *Nathan Oliveira and Max*, Stanford, California, 1990

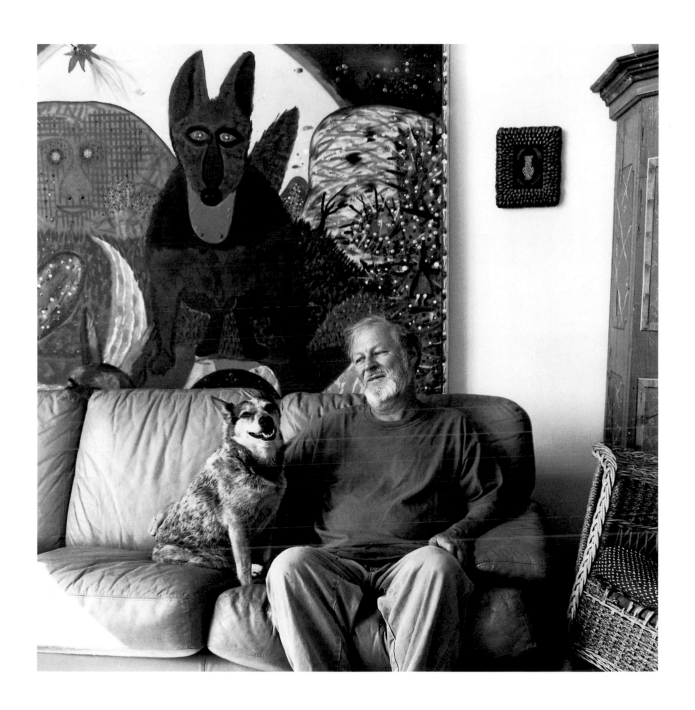

Leo Holub, *Roy De Forest and Pepe*, Port Costa, California, 1990

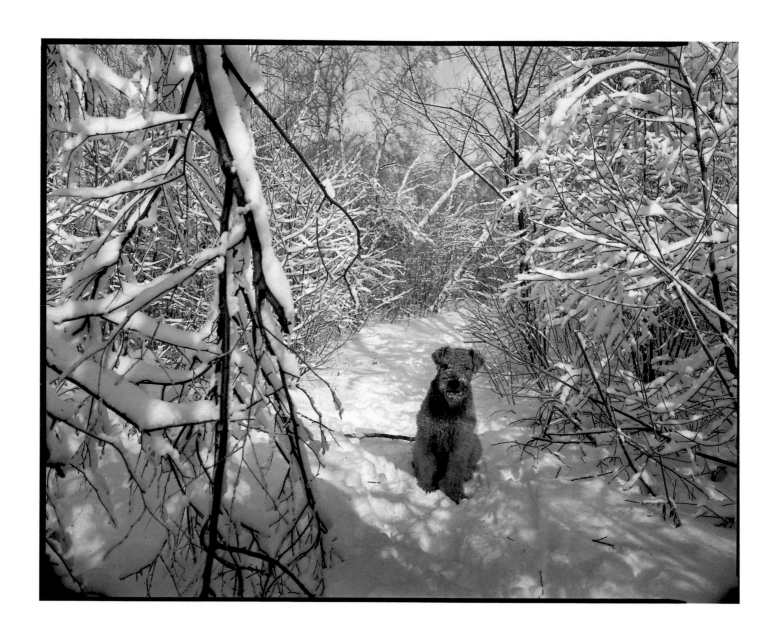

Nicholas Nixon, *Cambridge*, Massachusetts, 1982

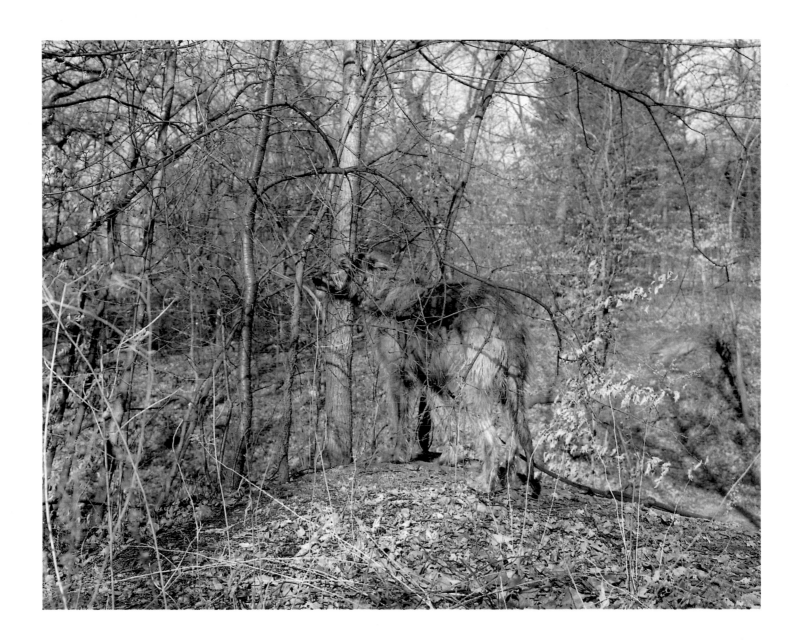

Gary Hallman, *Meynouth*, Minneapolis, 1990

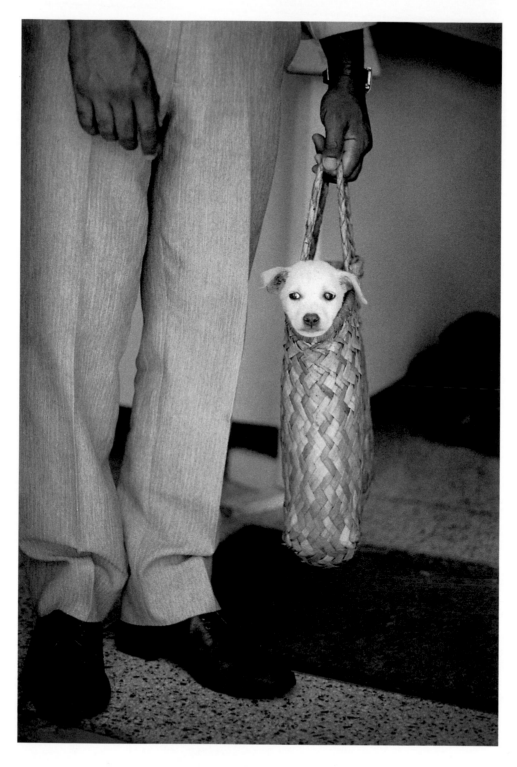

Michel Vanden Eeckhoudt, *Mauritius*, 1991

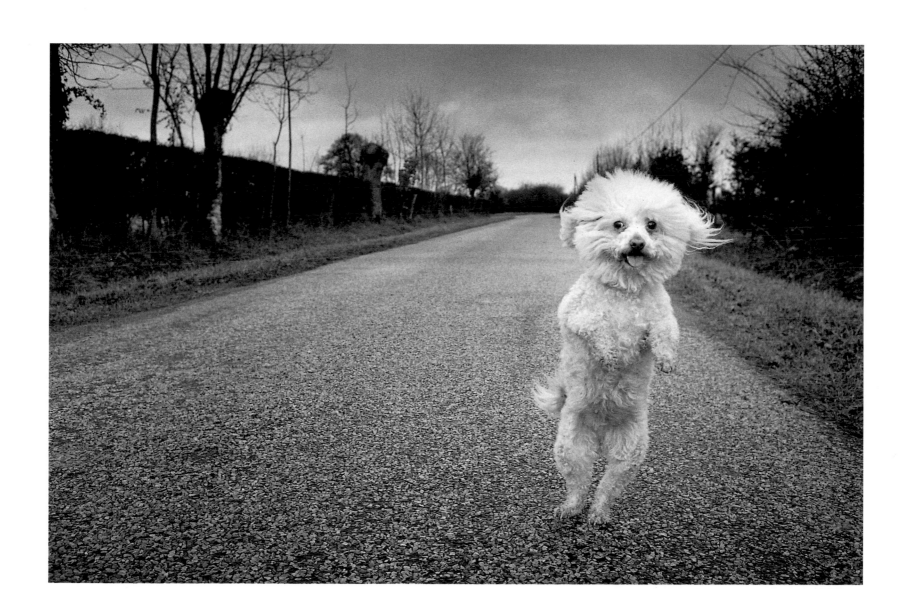

Michel Vanden Eeckhoudt, *Daisy*, France, 1996

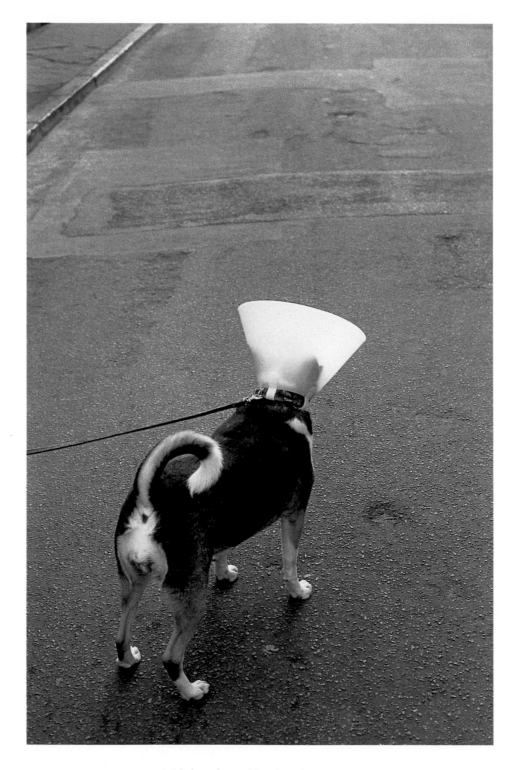

Michel Vanden Eeckhoudt, *Belgium*, 1987

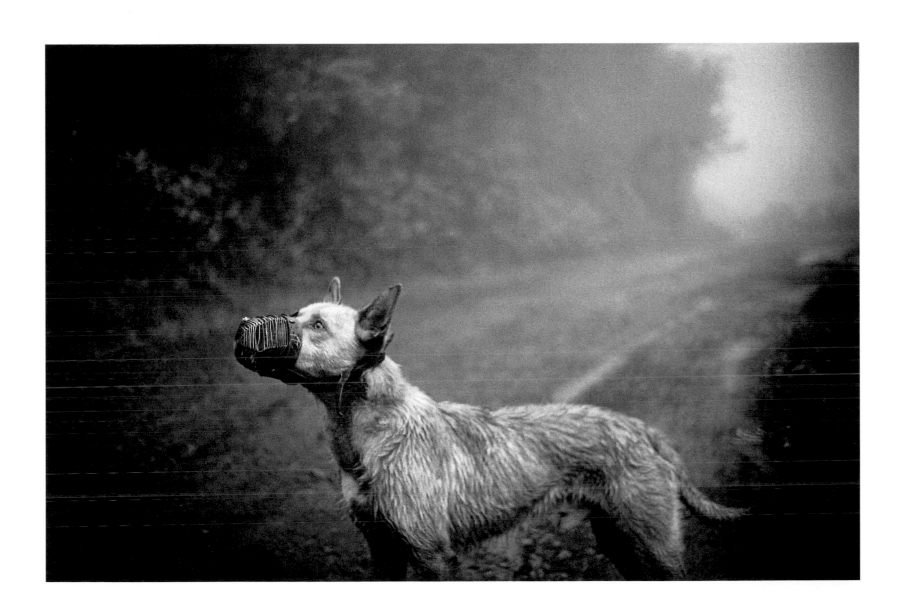

Michel Vanden Eeckhoudt, *Madeira*, 1994

Thomas Roma, *Frances* from *Sirius Studies*, Brooklyn, New York, 1981

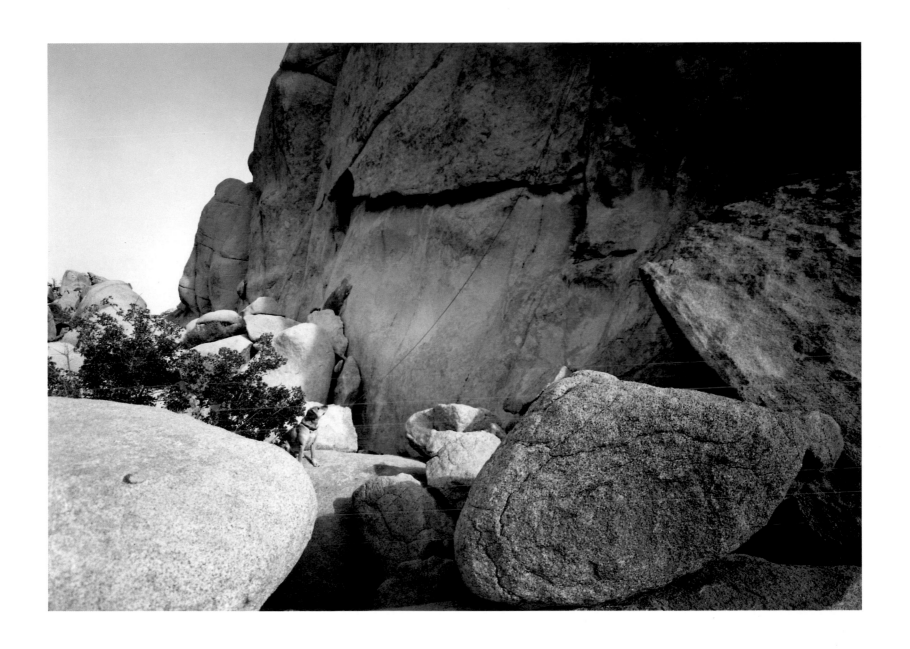

Paul Andrew Wegner, *Dog and Climber's Rope*, Joshua Tree National Monument, California, 1998

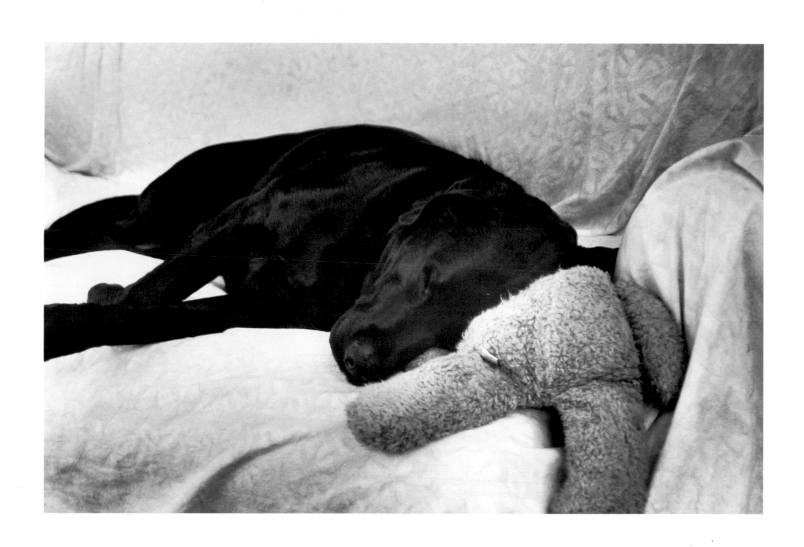

Zoe Eskin, *Claude*, Aspen, Colorado, February 1999

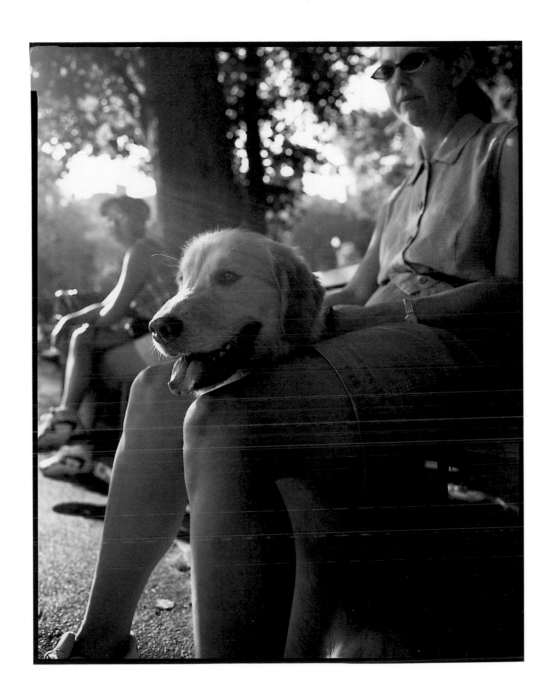

Nicholas Nixon, *Boston Common*, Massachusetts, 1999

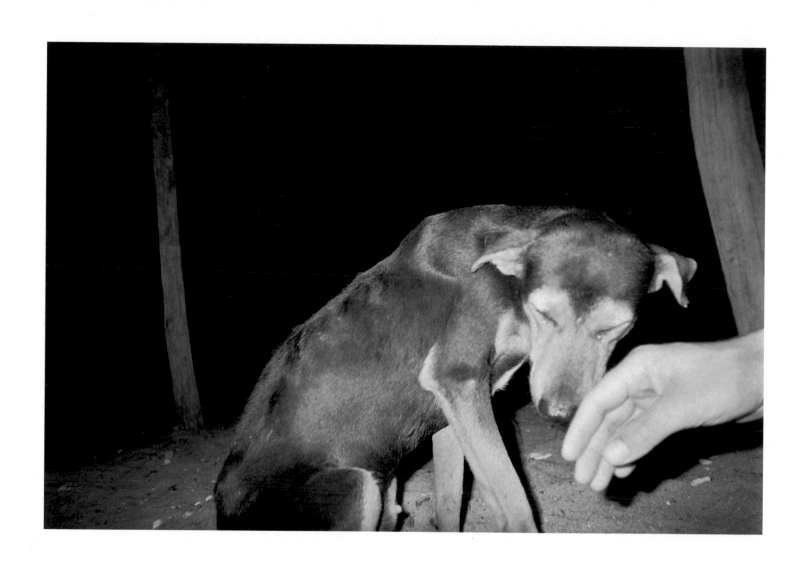

Patrick Piazza, *San Augustine Huatulco*, Oaxaca, March 1999

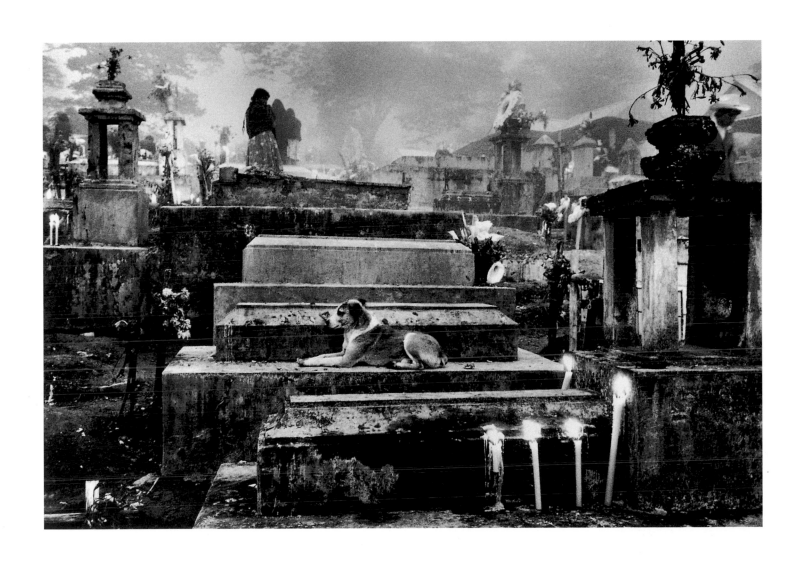

Sebastiao Salgado, *Hualta de Jimenez*, Mexico, 1980

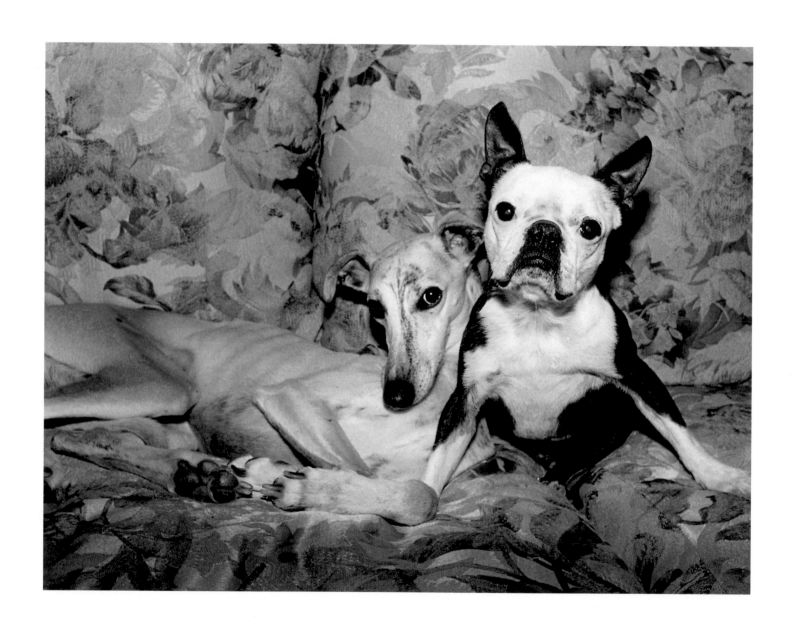

Robin Schwartz, *Peanuts and Harriet*, Cutchogue, New York, 1998

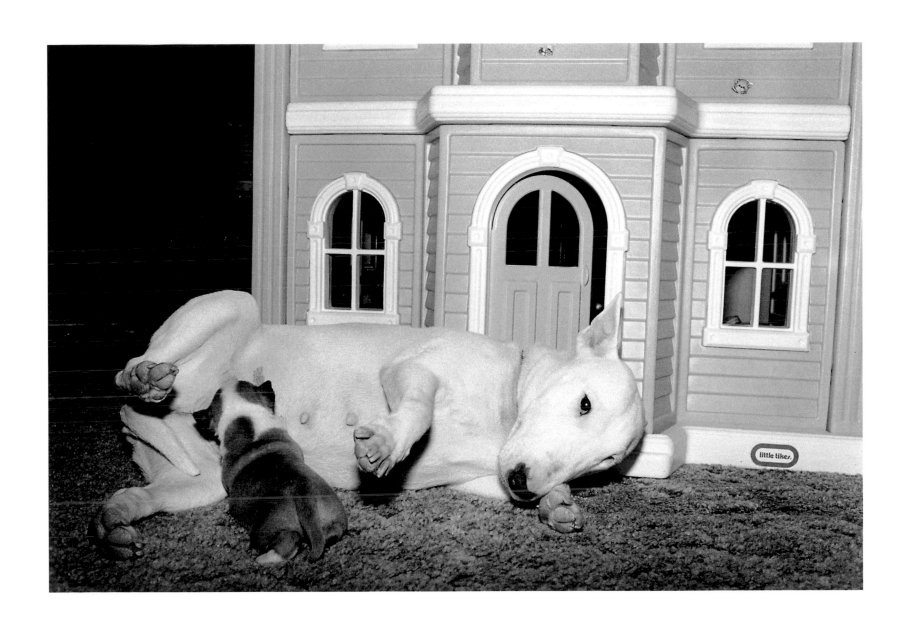

Robin Schwartz, *Crystal and Her Three-Week-Old Pup*, Torrington, Connecticut, 1994

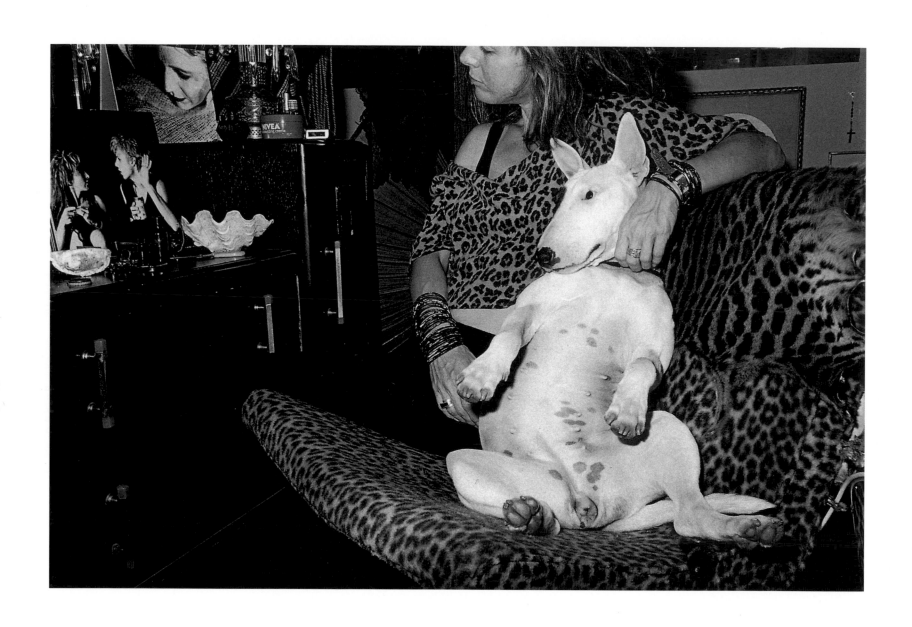

Robin Schwartz, *Missy and Pee Dee Rose Angelina*, Hoboken, New Jersey, 1987

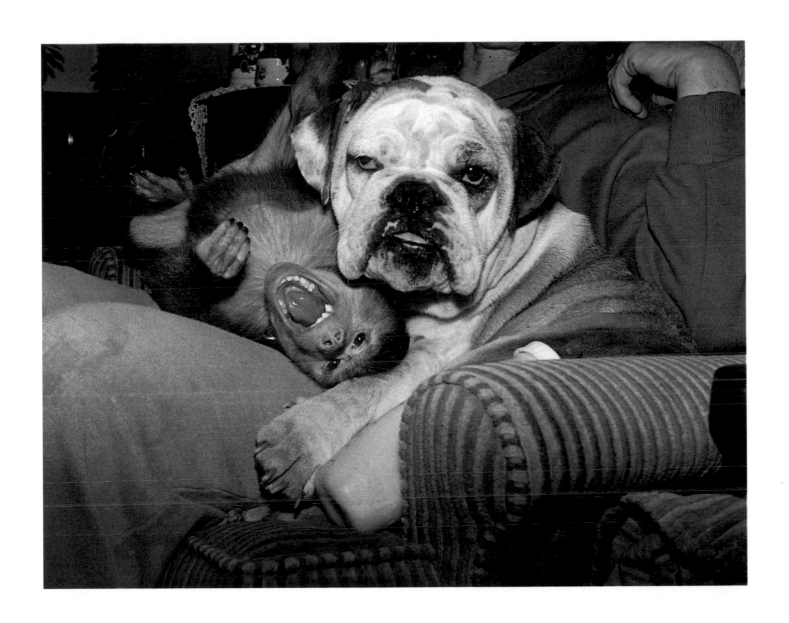

Robin Schwartz, *Jake and Tabitha,* Youngstown, Ohio, 1990

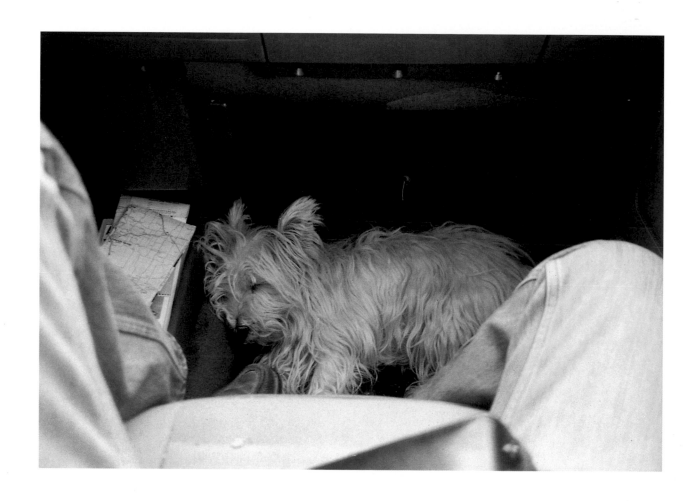

ABOVE: Kerstin Adams, *Sally at My Feet in the Car after a Long Hike on the Prairie*, Pawnee National Grasslands, Colorado, 1984

OPPOSITE: Robert Adams, *Sally in the Backyard*, Longmont, Colorado, 1990

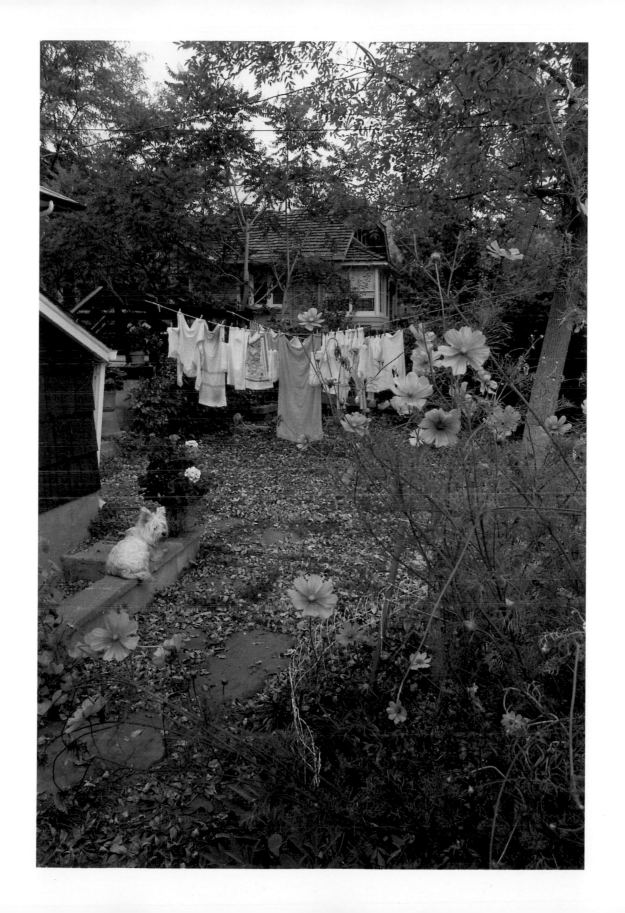

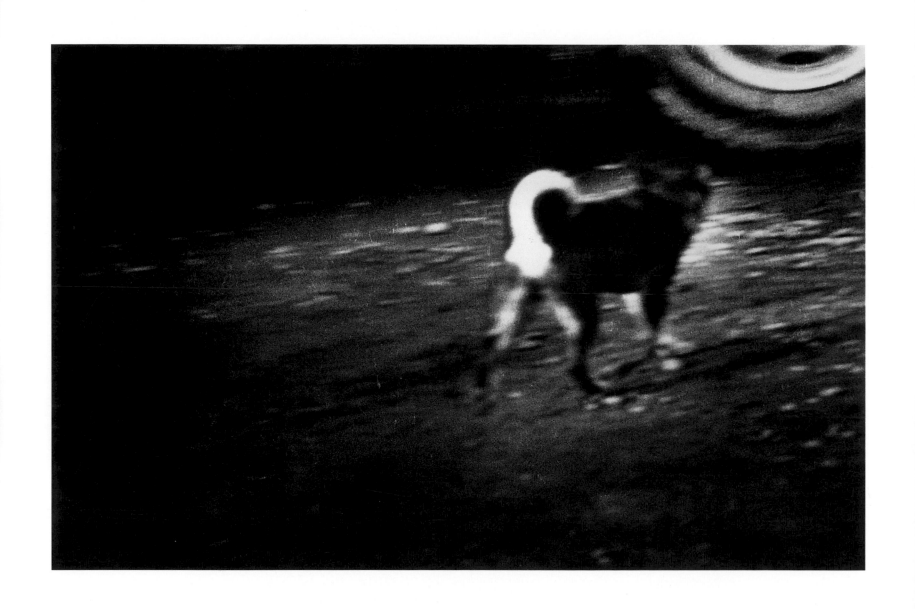

Daido Moriyama, *Route 16*, Saitama, Japan, 1969

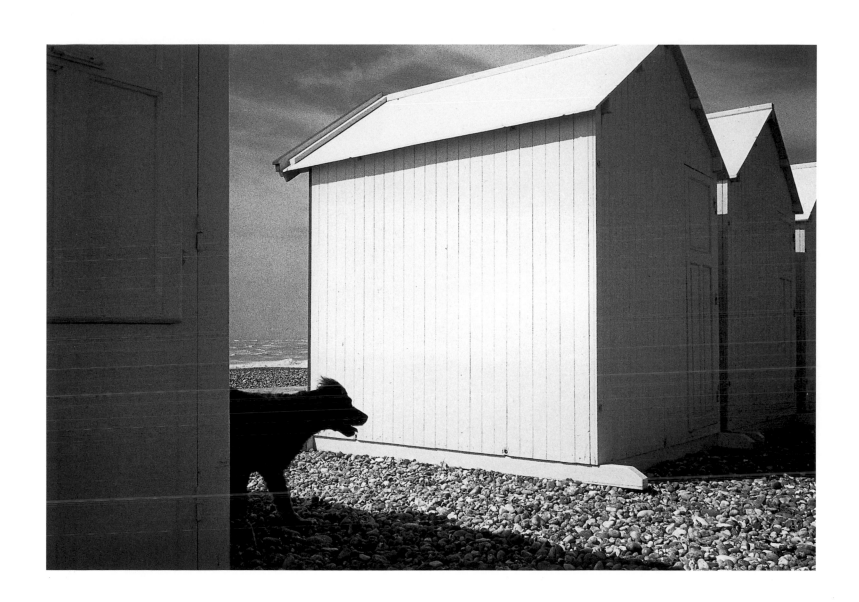

Michel Vanden Eeckhoudt, *On a Beach in Normandie*, France, 1981

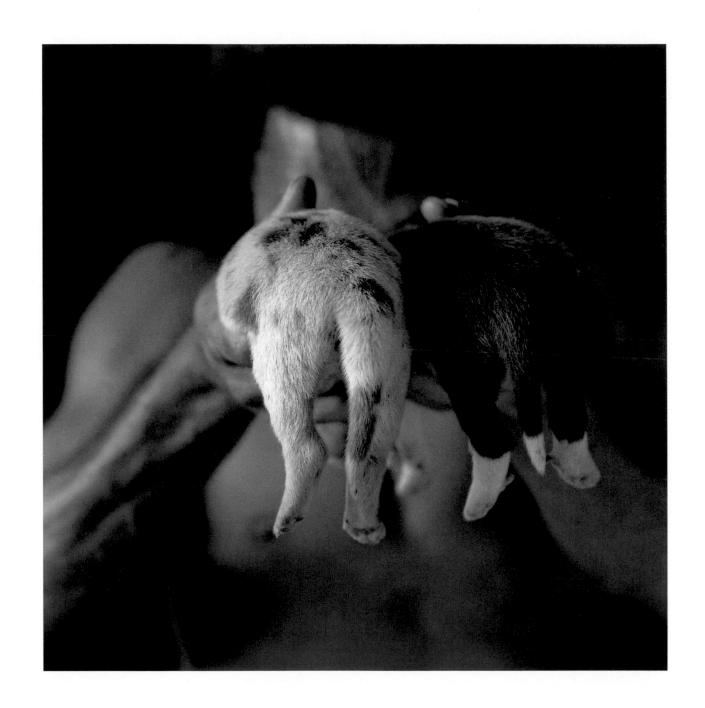

Mario Cravo Neto, *Pedro with Two Dogs*, Bahia, Brazil, 1989

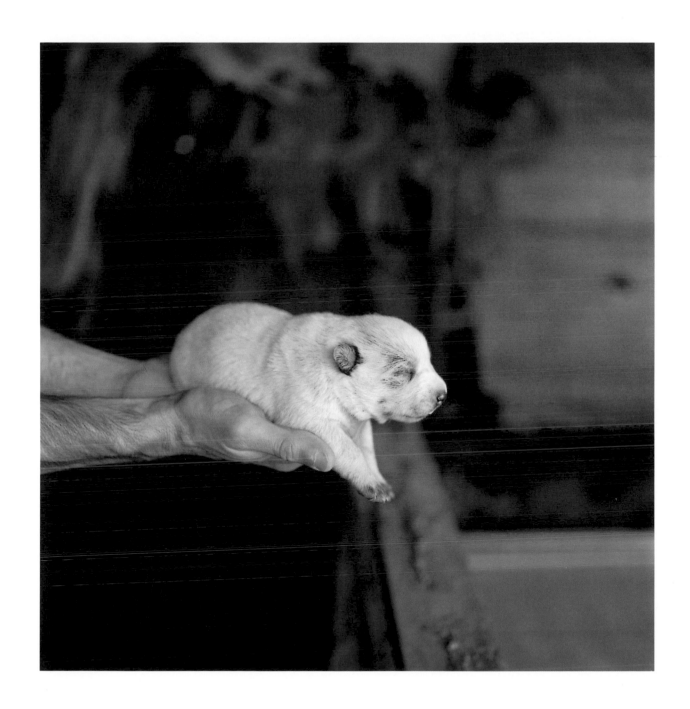

Melissa Lee Harris, *Untitled*, Iowa, 1995

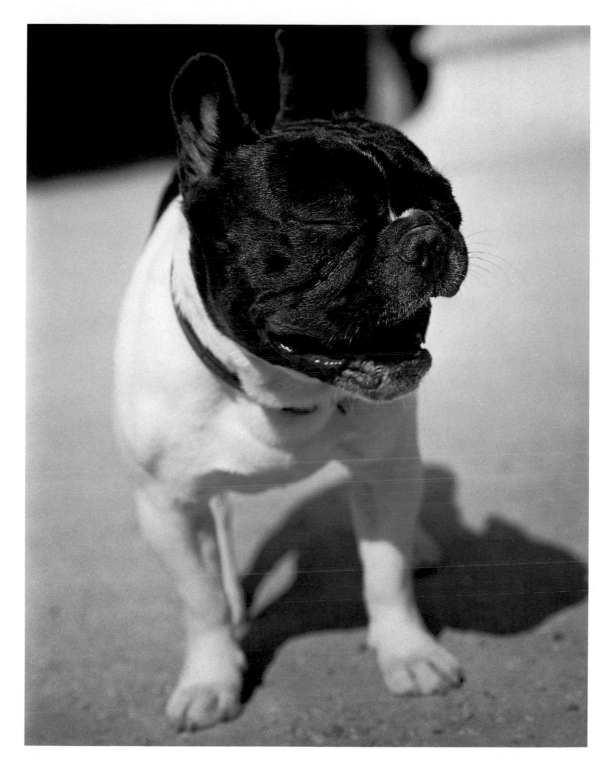

Bruce Weber, *French Bulldog*, Paris, 1990

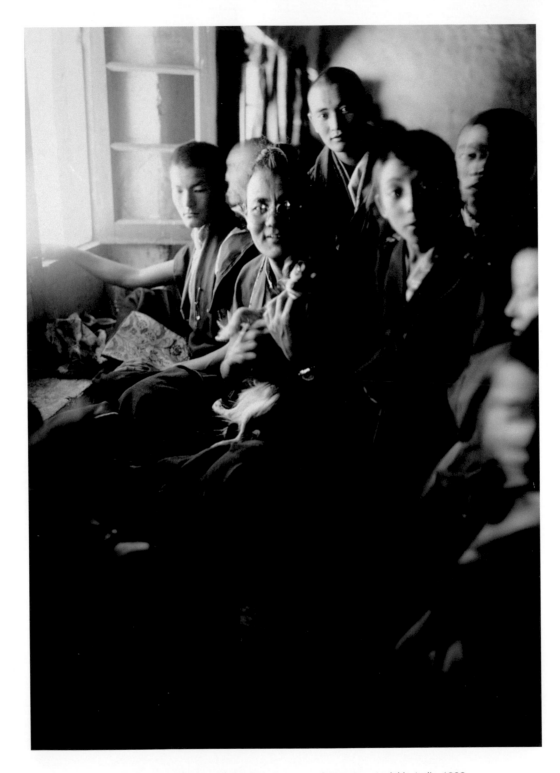

Linda Connor, *Monks with Pet Dog*, Lamayuru Monastery, Ladakh, India, 1998

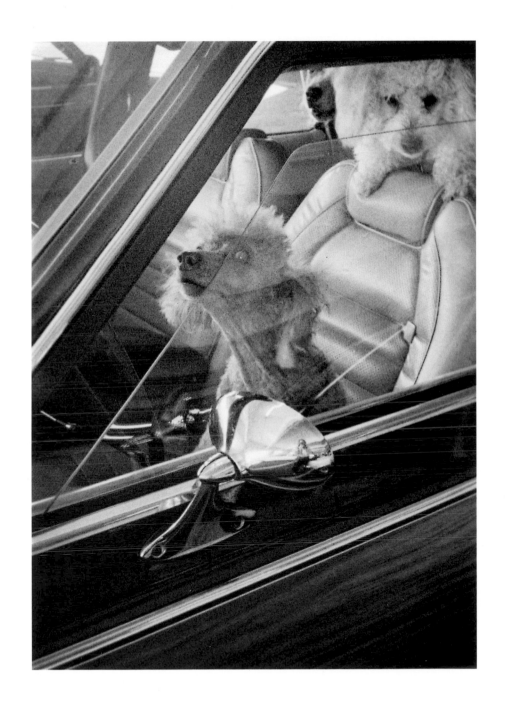

Gay Outlaw, *Poodle Driver*, San Francisco, California, 1992

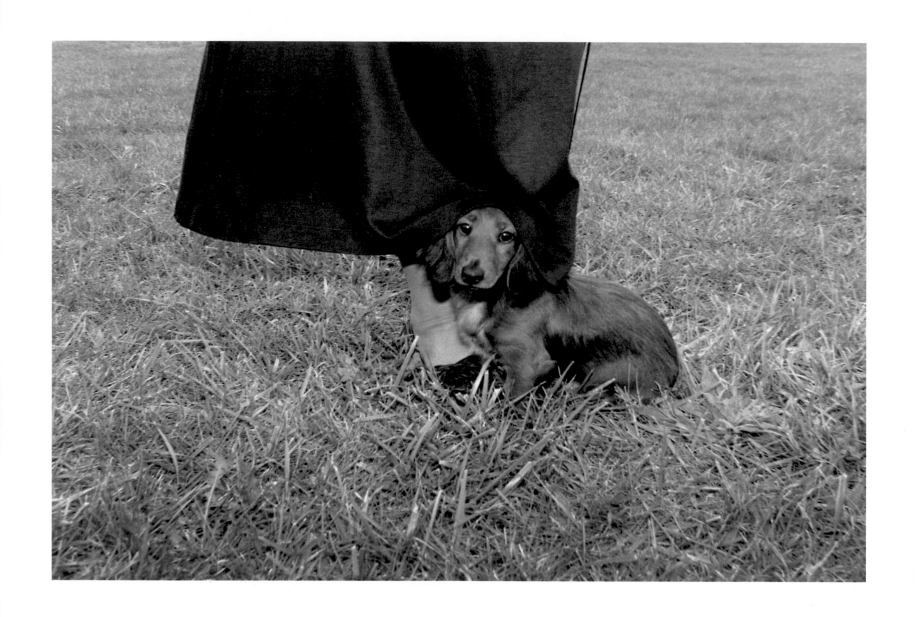

Karl Baden, *Rhode Island*, 1993

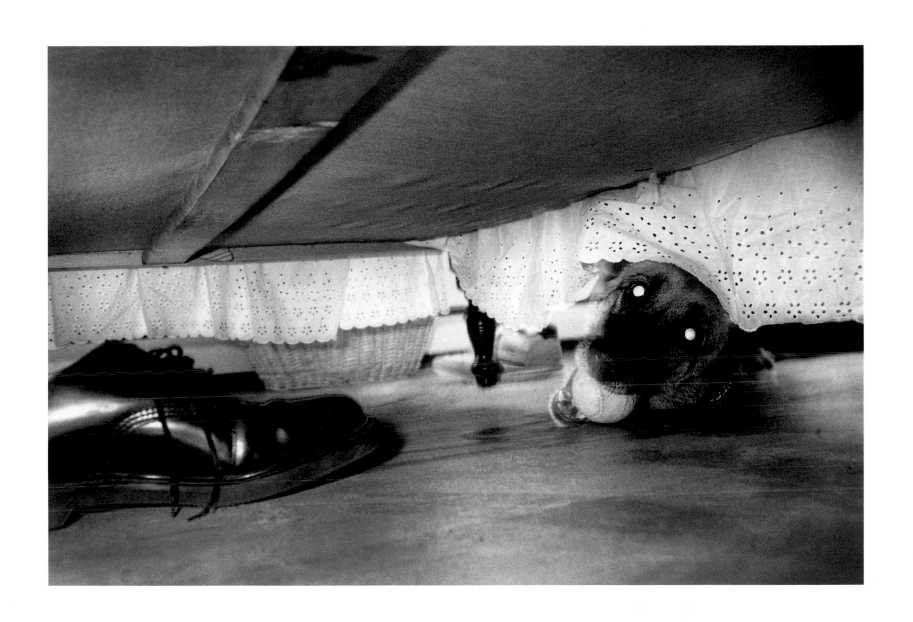

Karl Baden, *Charlotte*, Cambridge, Massachusetts, 1992

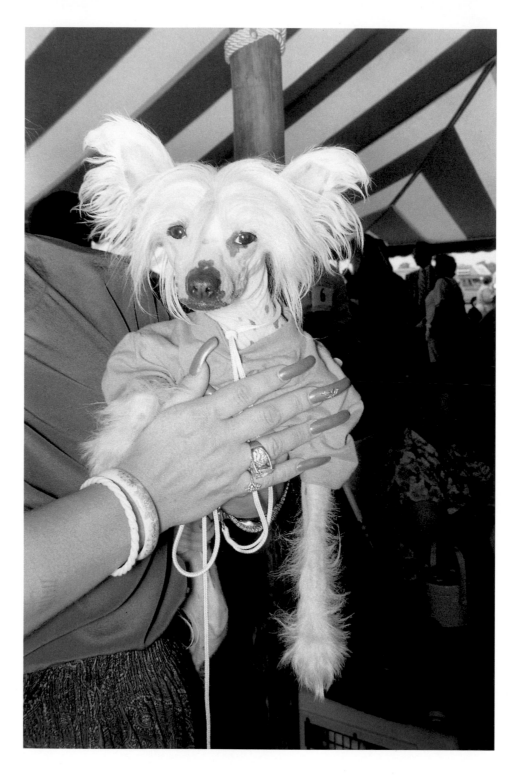

Karl Baden, *Chinese Crested*, Wrentham, Massachusetts, 1992

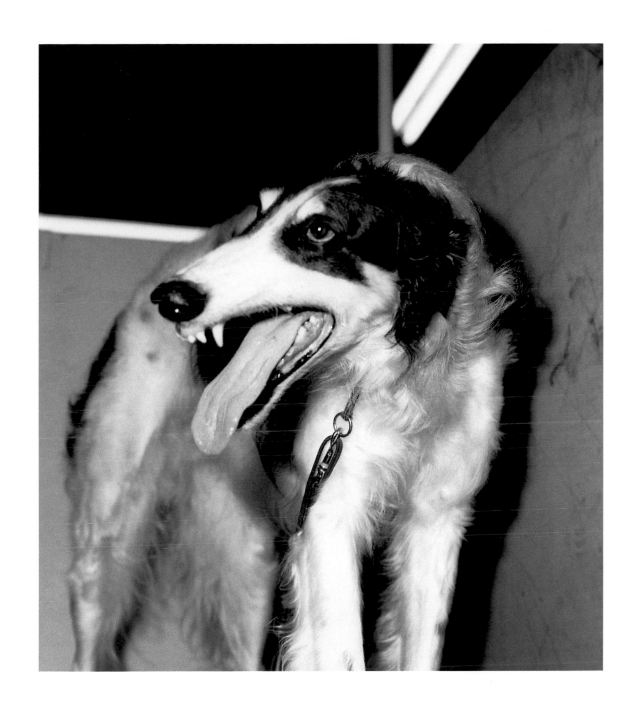

Leon Borensztein, *Dog Show*, San Francisco, California, 1980

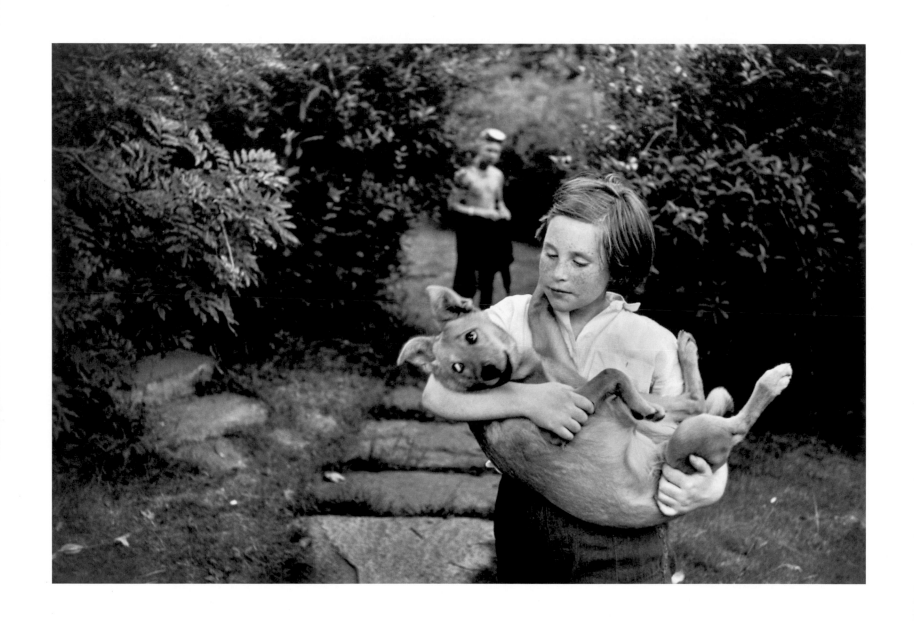

Elliott Erwitt, *Armonk*, New York, 1995

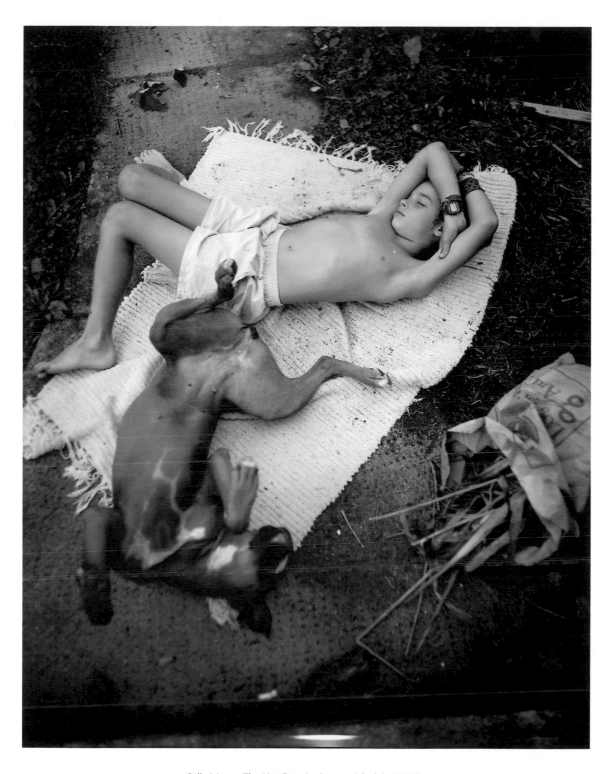

Sally Mann, *The Hot Dog*, Lexington, Virginia, 1989

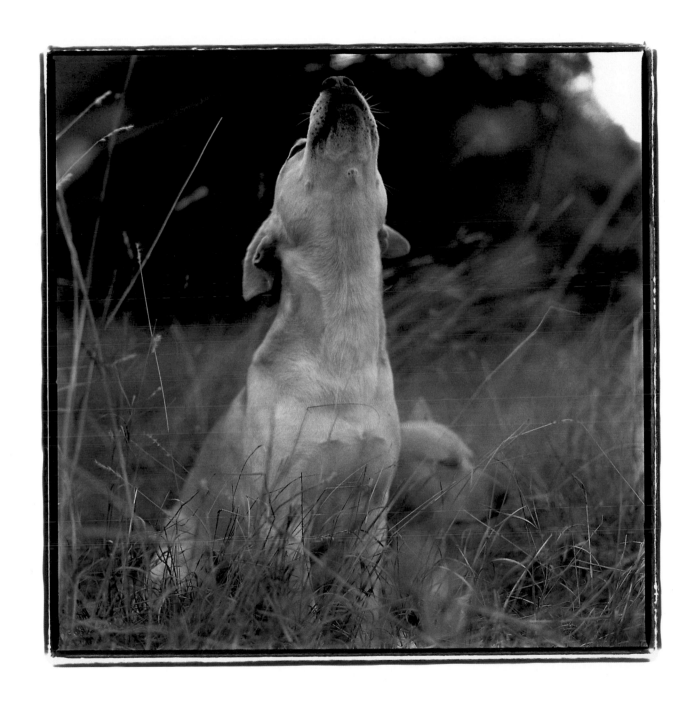

Keith Carter, *Howling*, Texas, 1993

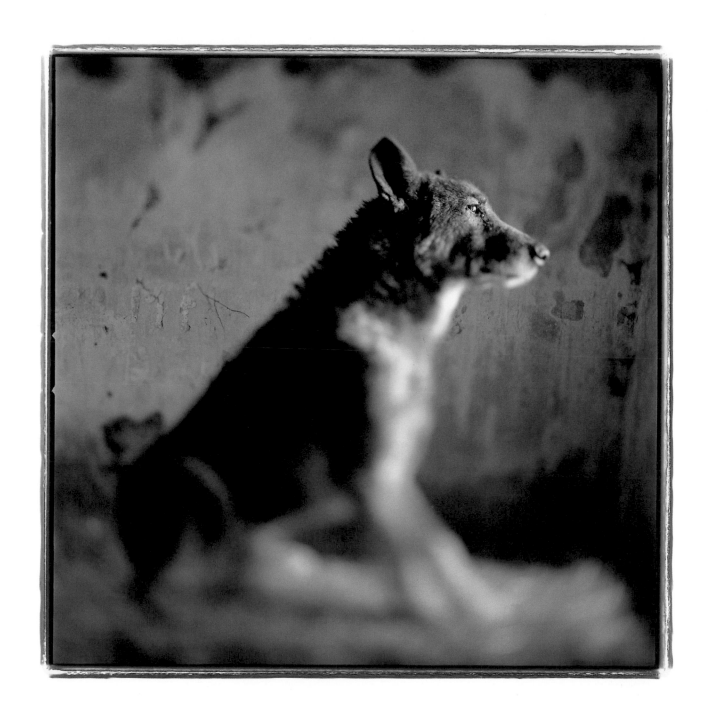

Keith Carter, *Lupo*, Italy, 1998

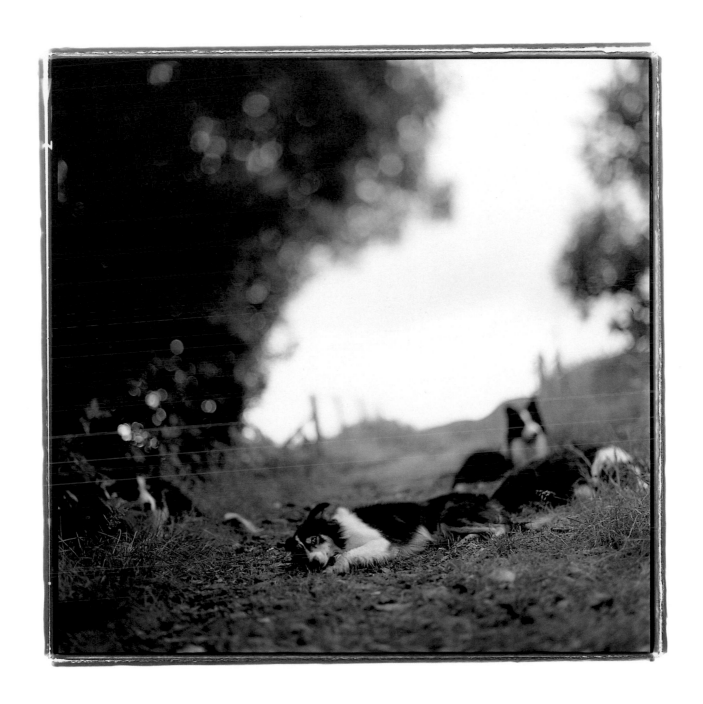

Keith Carter, *Sheepdogs*, Scotland, 1998

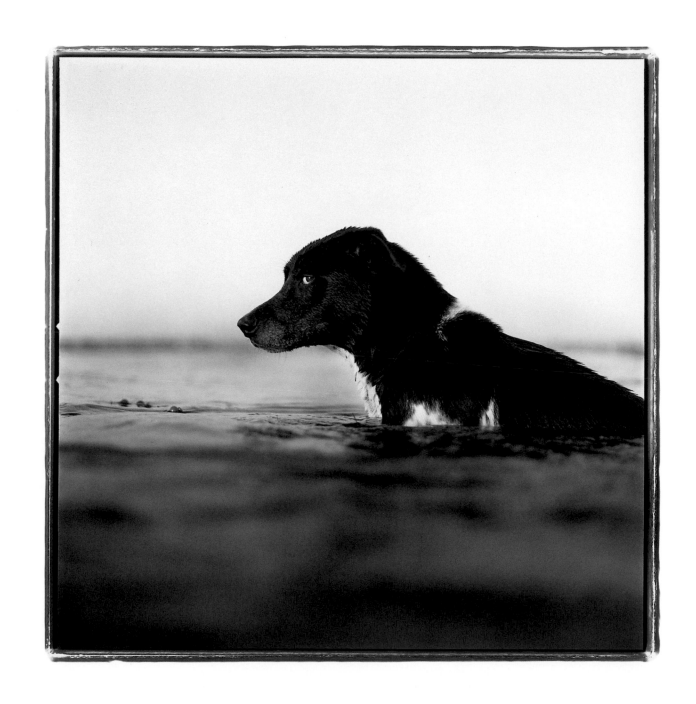

Keith Carter, *Dog Beach*, San Diego, California, 1995

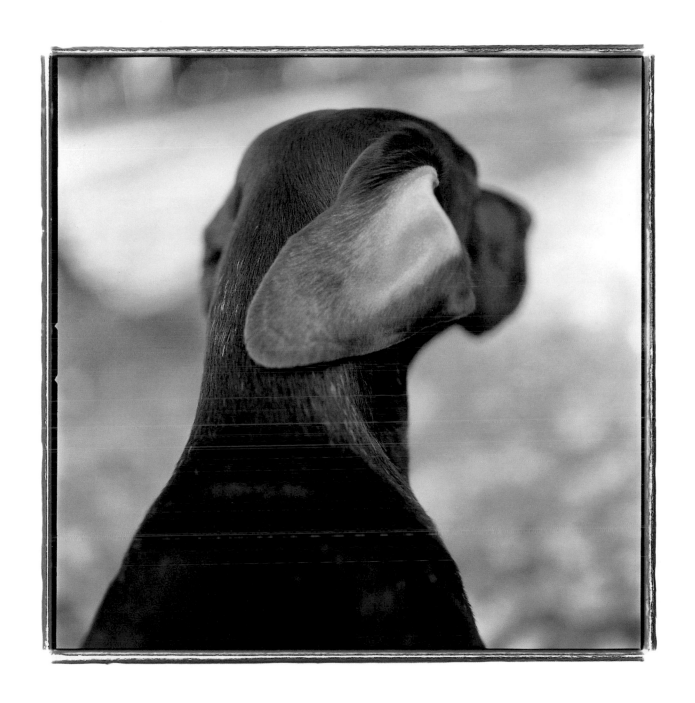

Keith Carter, *Short Hair*, 1995

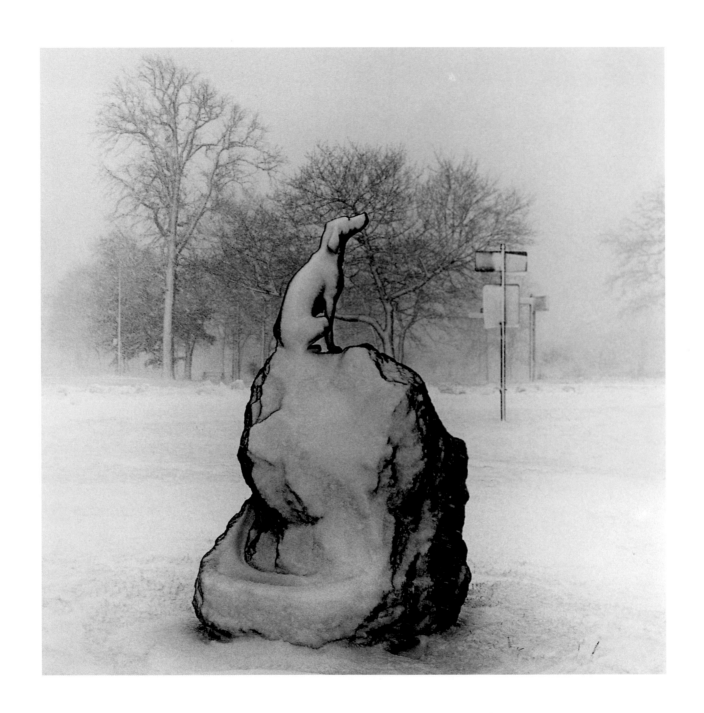

Bill Schwab, *Snow Dog*, Belle Isle, Detroit, Michigan, 1996

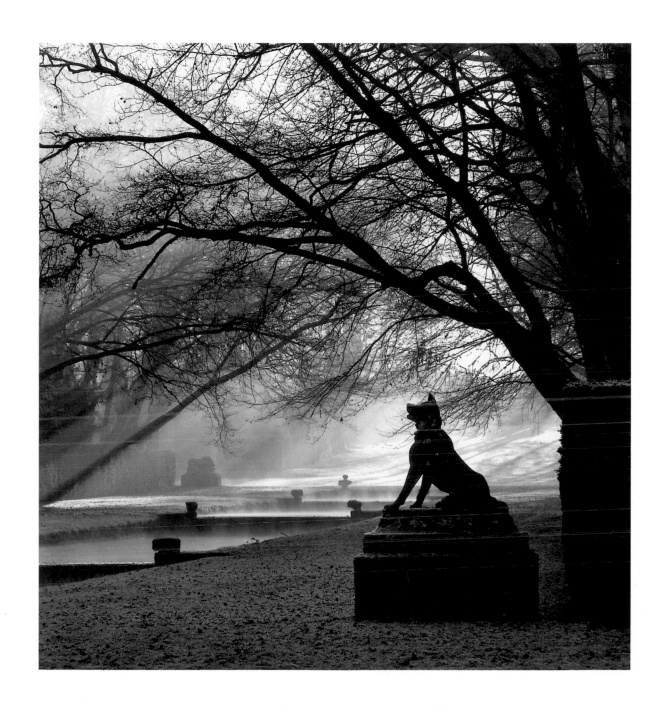

Michael Kenna, *Guardian Wolf*, Courances, France, 1997

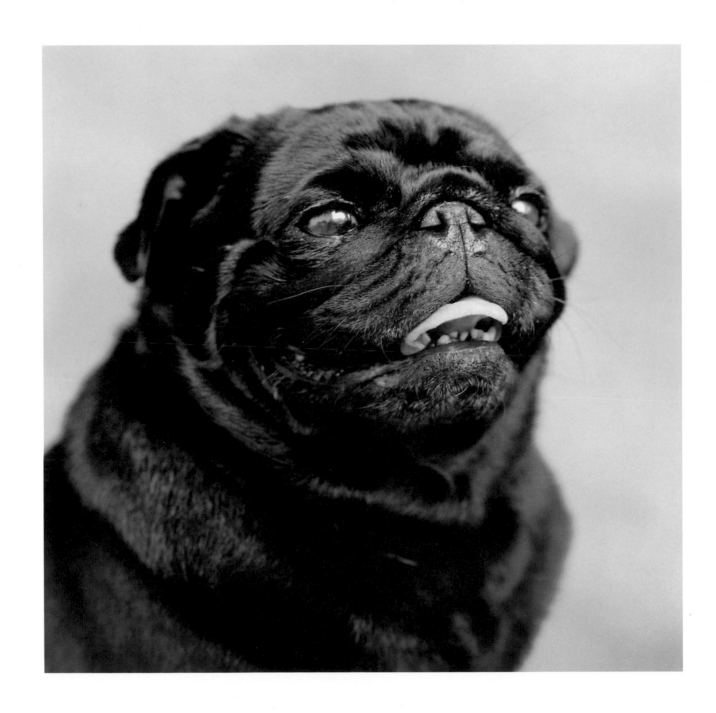

Valerie Shaff, *Carmen*, 1995

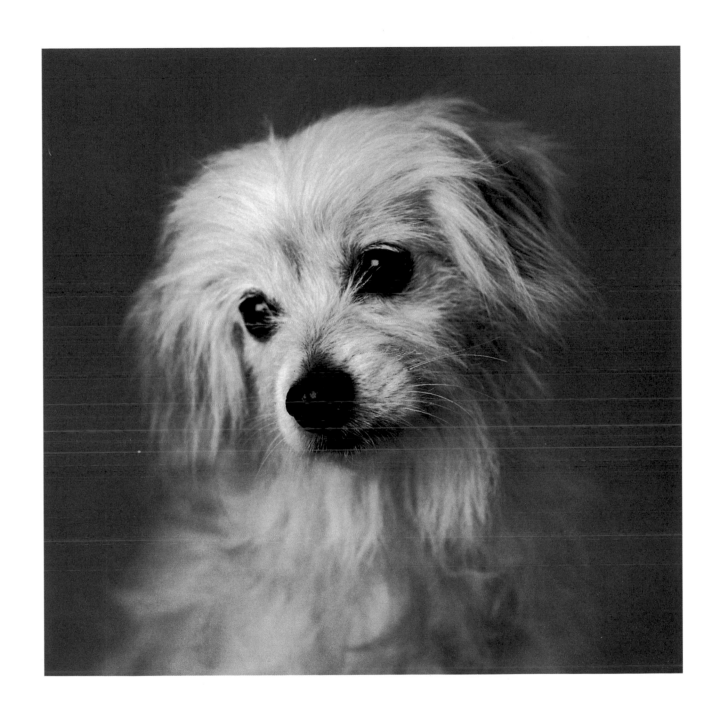

Valerie Shaff, *Fran*, 1996

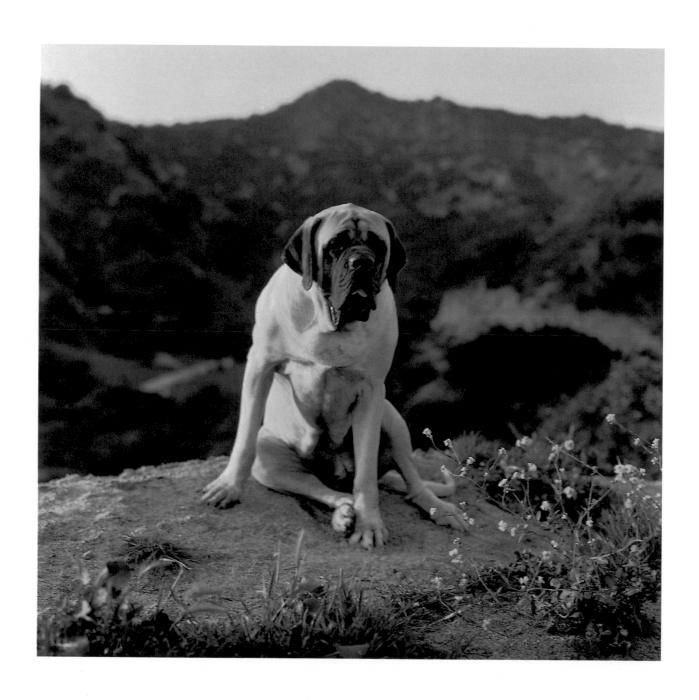

Valerie Shaff, *Betty*, Los Angeles, California, 1996

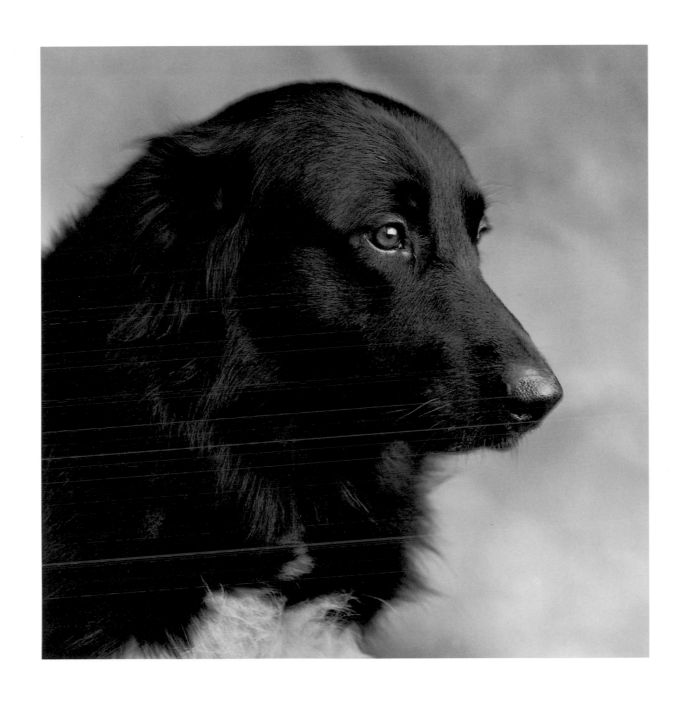

Valerie Shaff, *Samantha*, 1995

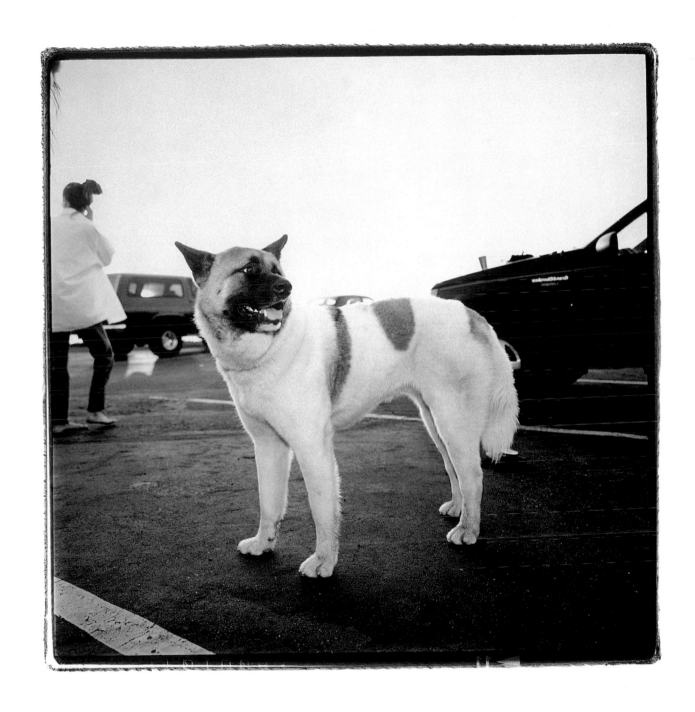

Annie Leibovitz, *Eyewitness: Nicole Brown Simpson's Akita, Kato*, Laguna Beach, California, 1995

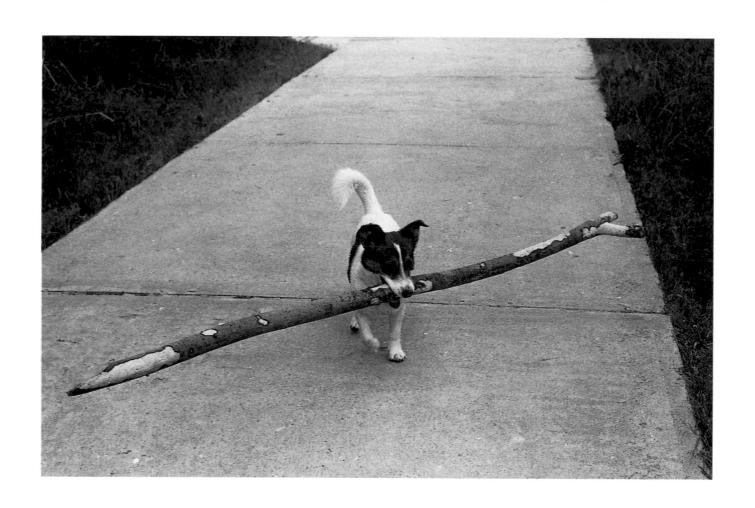

Alen MacWeeney, *Bachelor on Holiday*, Fire Island, New York, 1992

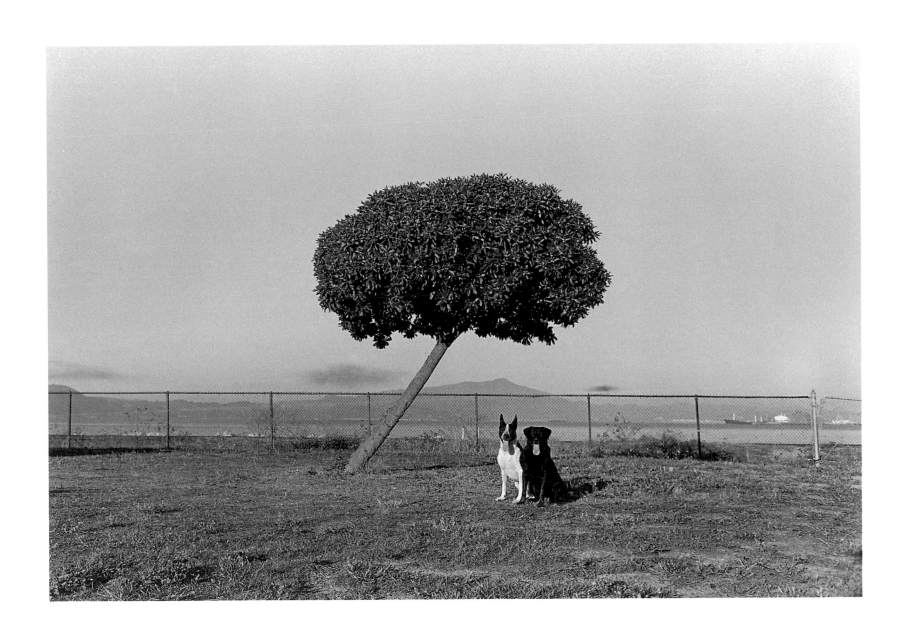

Henry Wessel, *Pekoe and Tasha*, Point Richmond, California, 1987

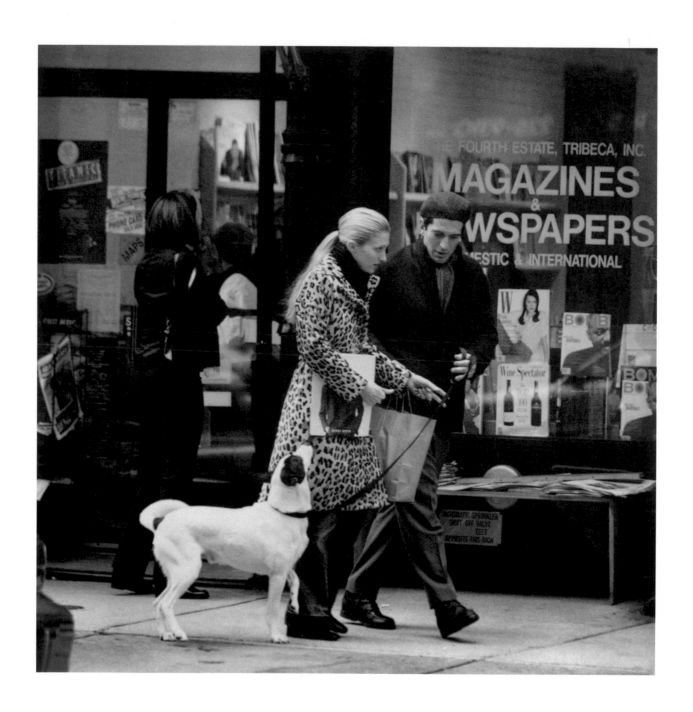

Brad Rickerby, *John F. Kennedy Jr., Carolyn Bessette Kennedy, and Dog, Friday*, New York, December 20, 1997

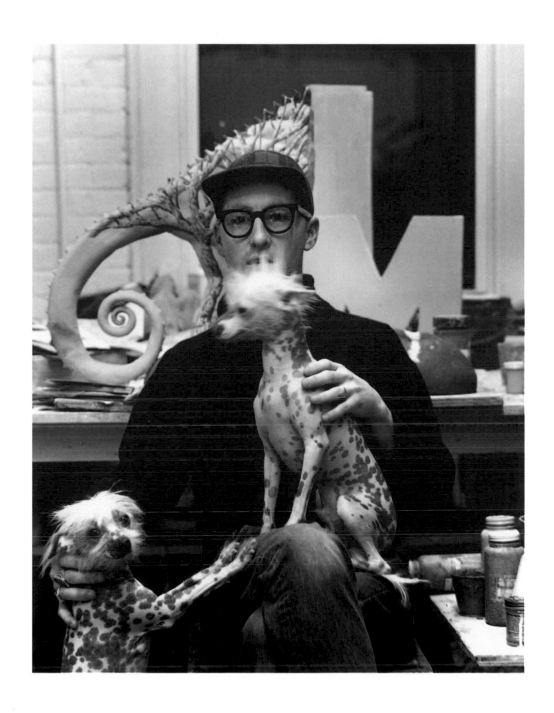

Leo Holub, *Michael Lucero with His Chinese Crested Hairless Dogs*, New York, 1986

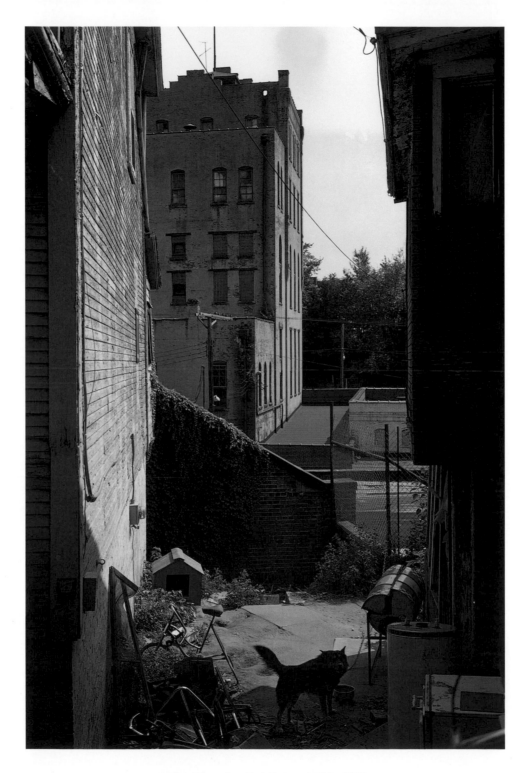

Andrew Borowiec, *East Liverpool*, Ohio, 1986

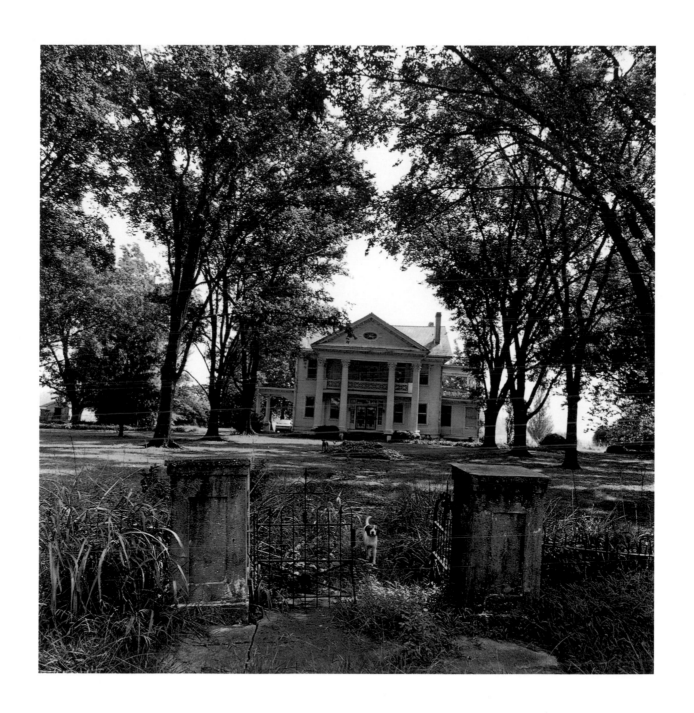

Ken Light, *Millen Farms*, Drew, Mississippi, 1991

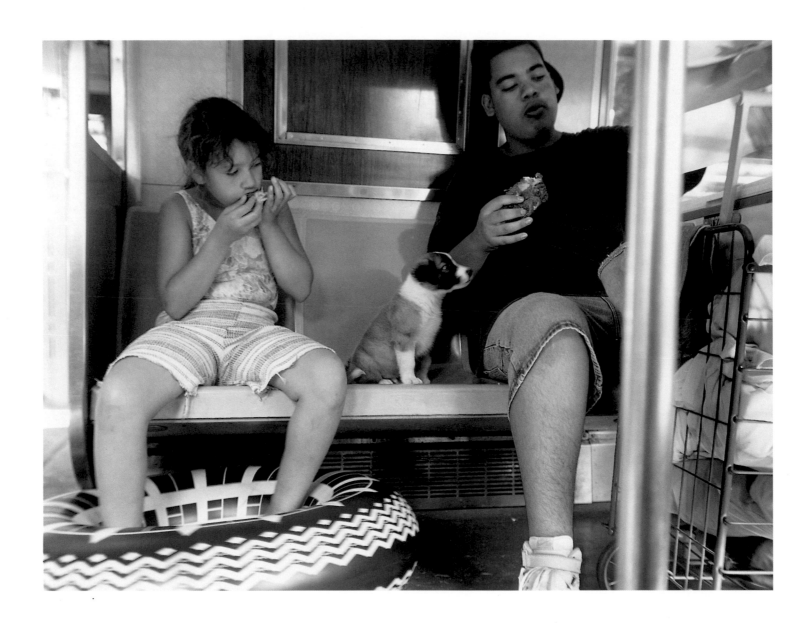

Thomas Roma, *Untitled*, Brooklyn, New York, 1995, from *Higher Ground*

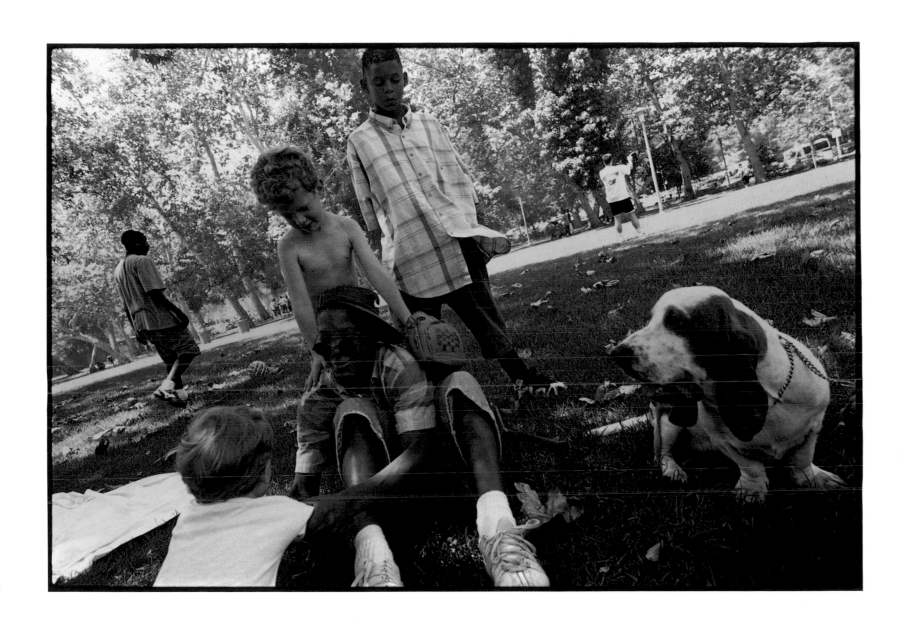

Stephen Shames, *Picnic for Bresee Youth*, Los Angeles, California, 1996

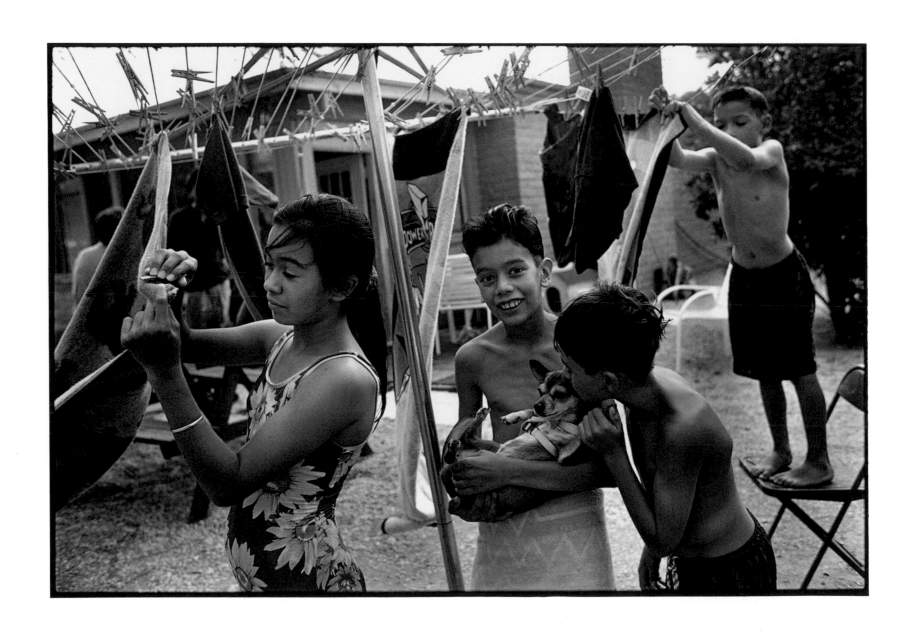

Susie Fitzhugh, *Backyard in Tucson*, Arizona, 1996

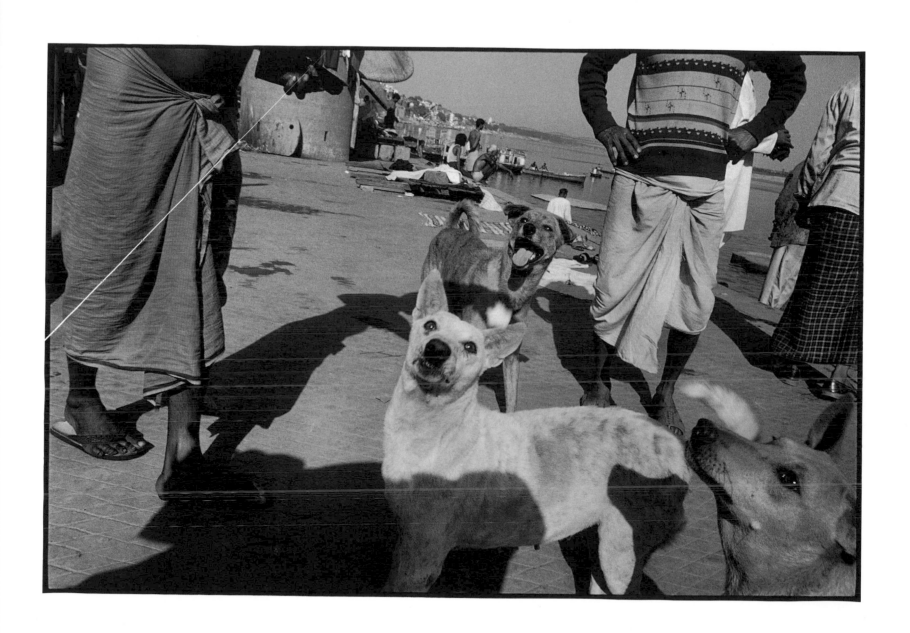

Bruce Gilden, *Three Dogs*, India, 1998

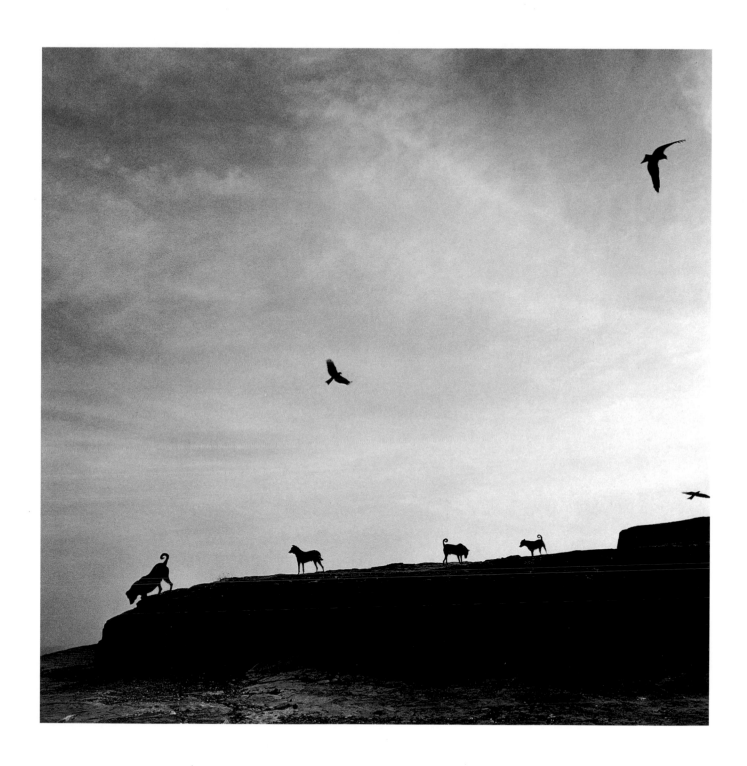

Graciela Iturbide, *Perros Perdidos*, India, 1998

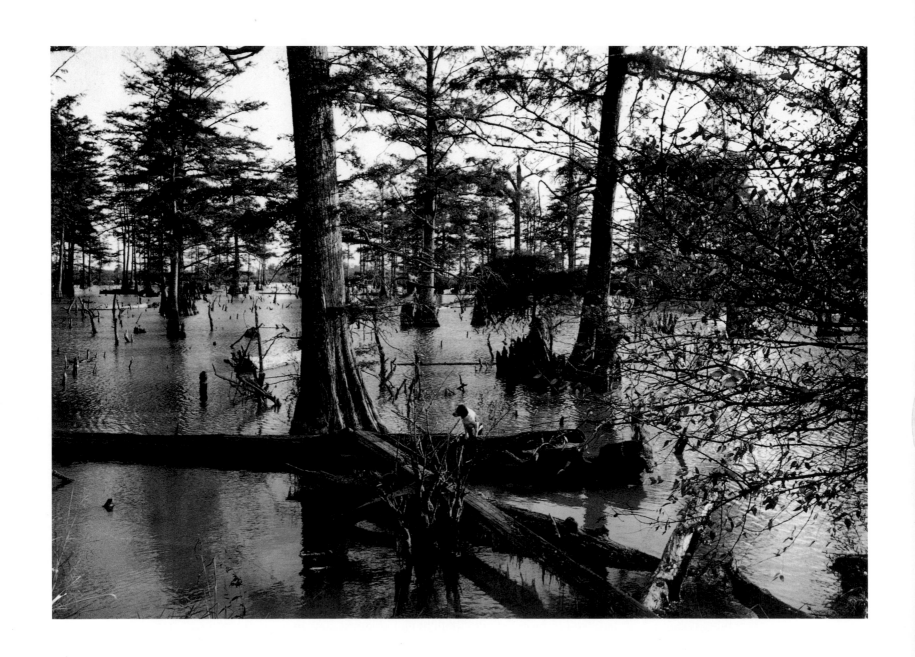

Maude Schuyler Clay, *Dog on a Log*, Sandy Bayou, near Glendora, Tallachatchie County, Mississippi, 1993

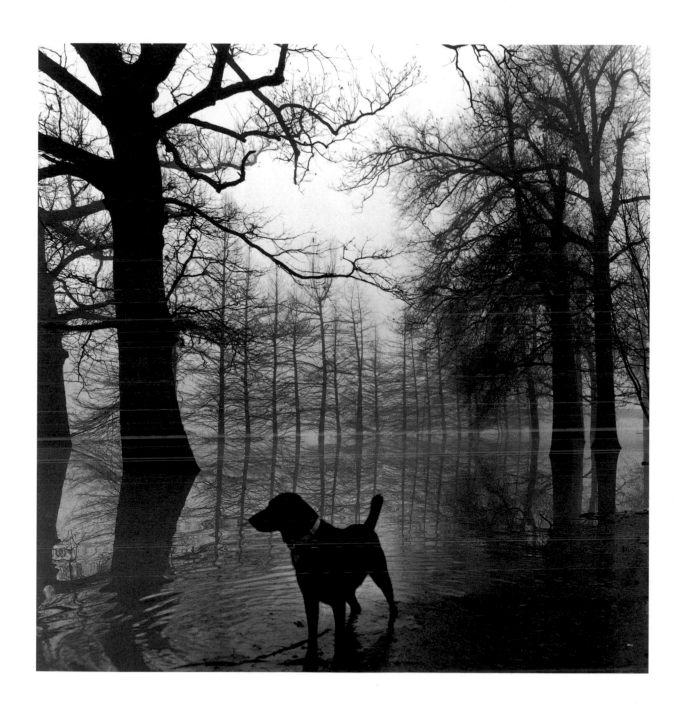

Maude Schuyler Clay, *Dog in the Fog*, Cassidy Bayou, Sumner, Tallachatchie County, Mississippi, 1997

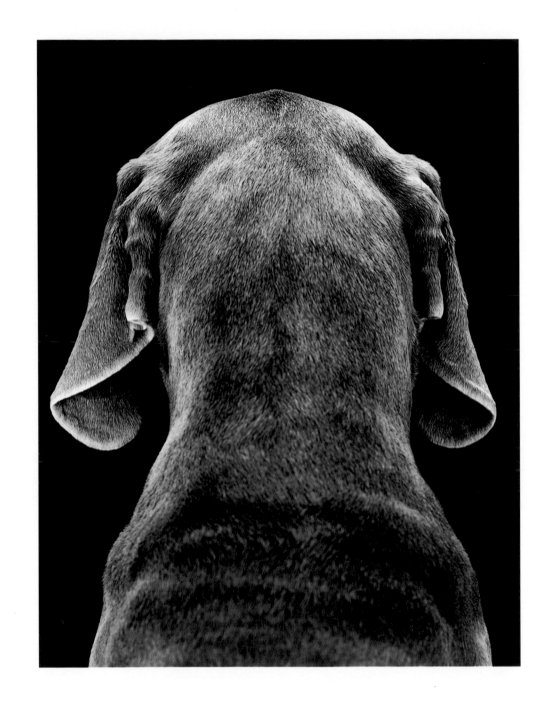

William Wegman, *Curly*, 1999

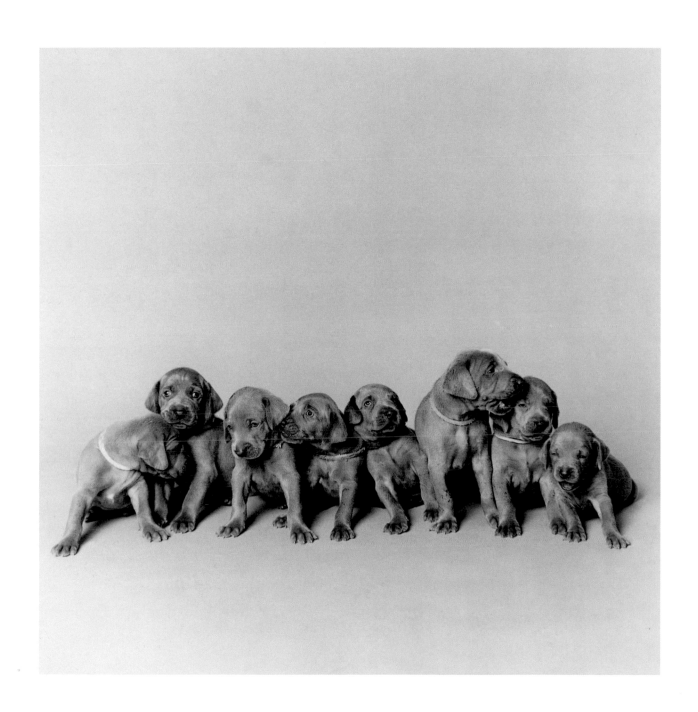

Willliam Wegman, *The Group*, 1989

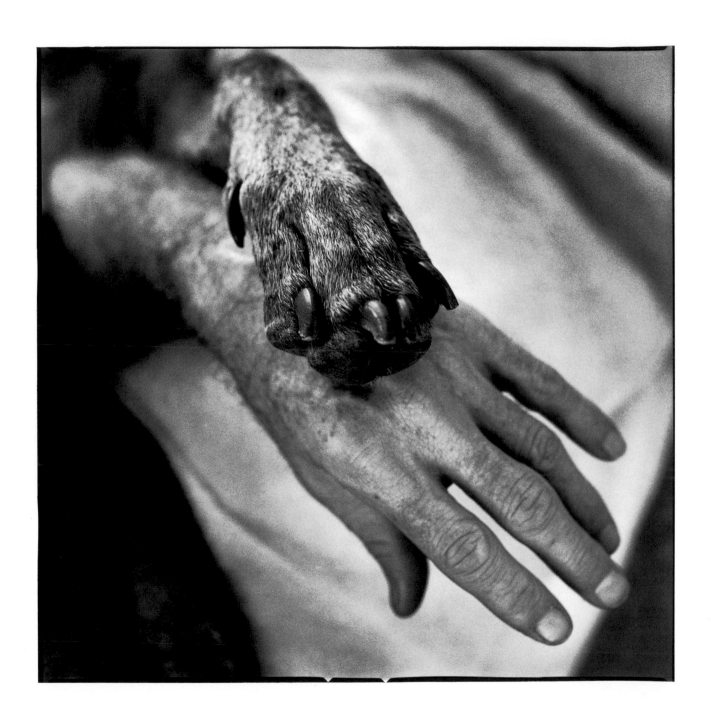

Arthur Tress, *Paw and Hand*, 1999

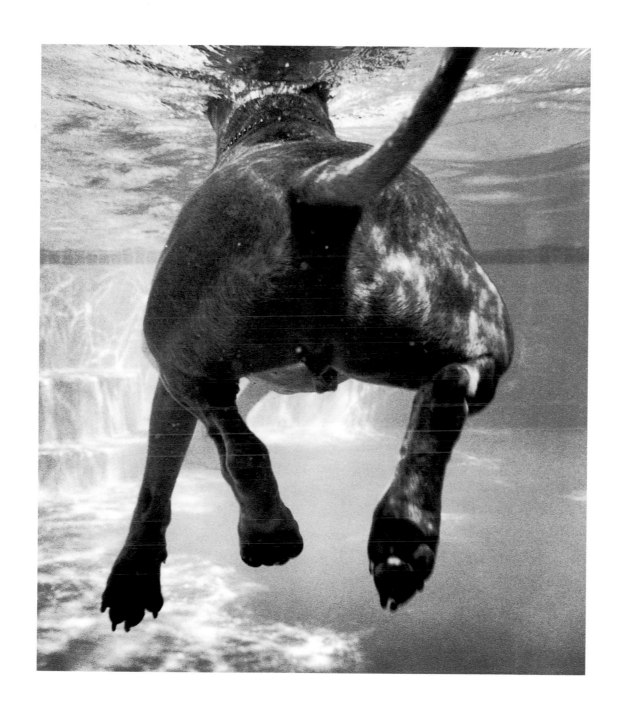

Matt Caputo, *Year's End Greetings (Truman)*, 1998

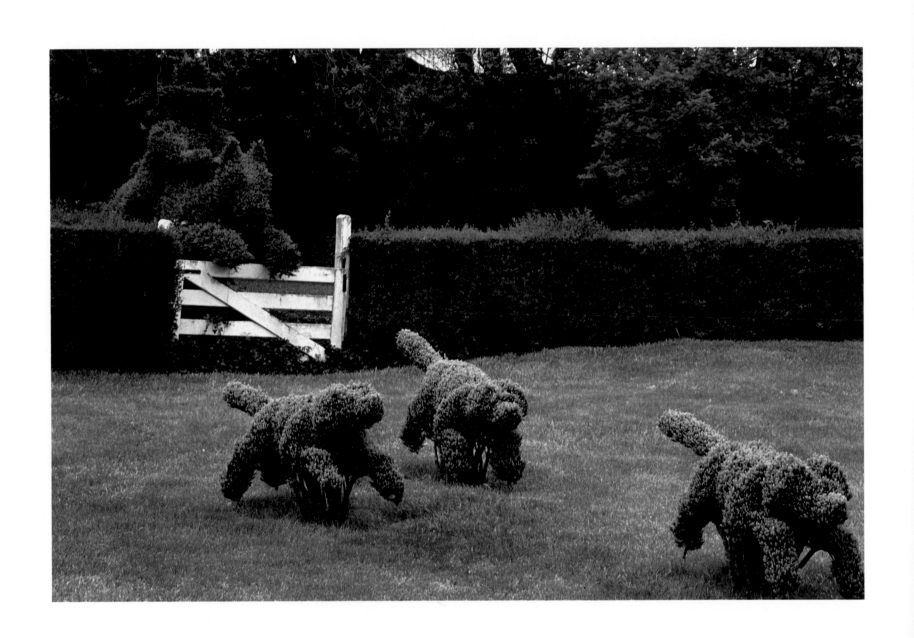

Langdon Clay, *Foxhunt Topiary, Ladew Topiary Garden*, Monkton, Maryland, 1991

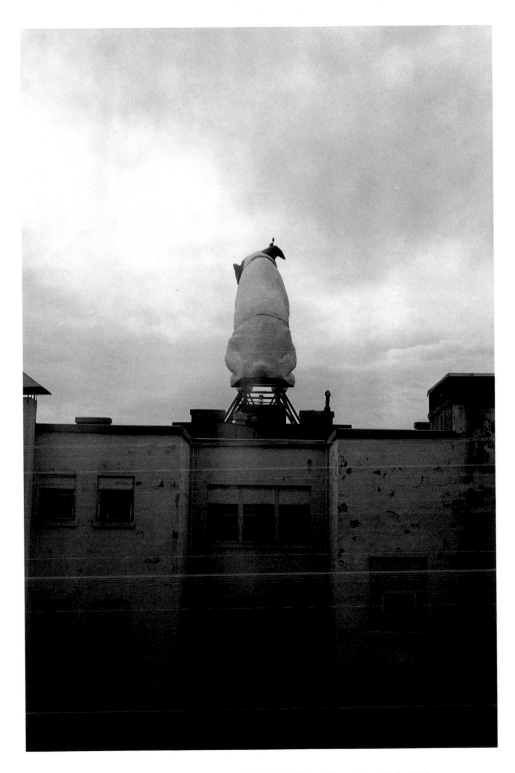

Charles Linder, *There IS a Dog, Old RCA Building*, Albany, New York, 1998

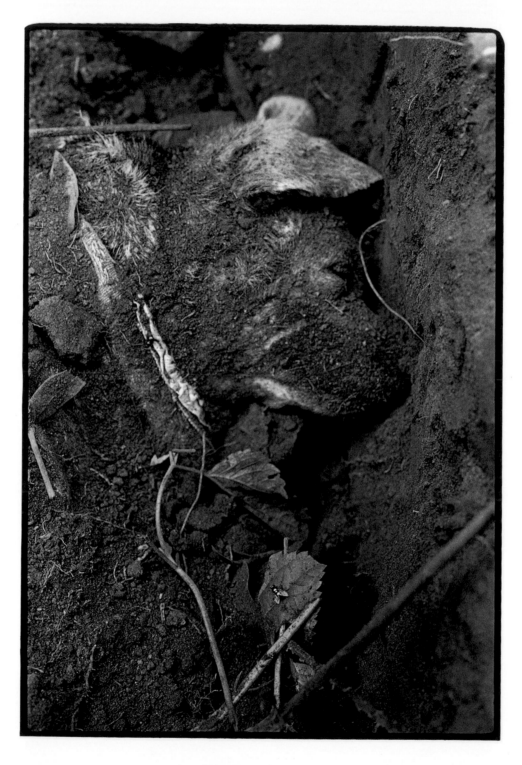

Sylvia Plachy, *Poco*, 1982

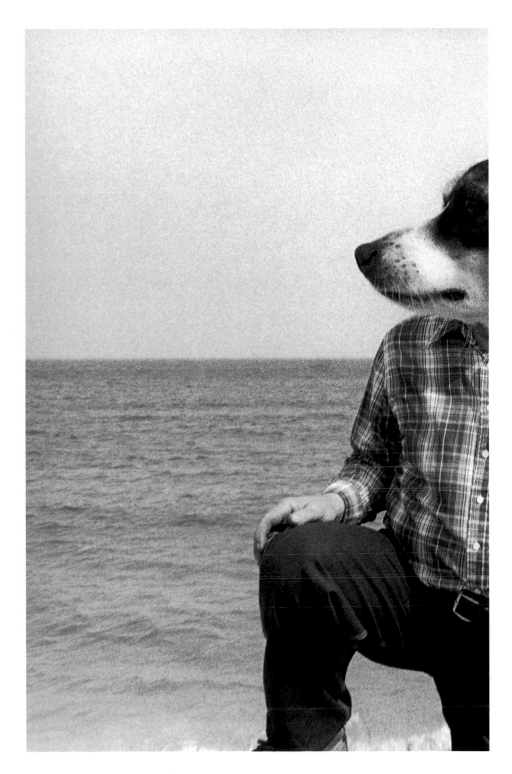

Karl Baden, *Revere*, Massachusetts, 1992

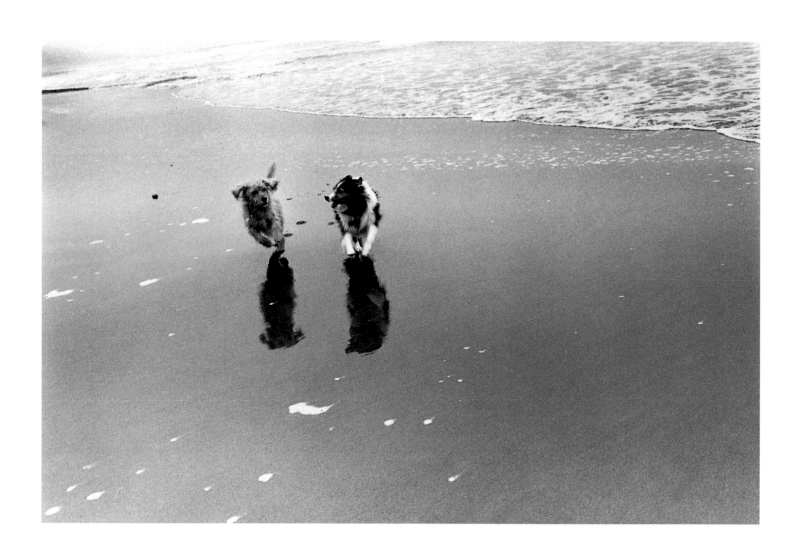

Asako Shimazaki, *Jeff and Taro*, San Francisco, California, 1994

Acknowledgments

Without the contributions of many, no book that attempts to be a survey could actually survey—or become a book.

I offer my greatest appreciation to the photographers and other sources mentioned in the credits who gracefully took on unanticipated and additional work on behalf of this book. I would like to offer special kudos to photographer Linda Connor, who reviewed her vast "photographic memory" to find several of the most wonderful images without my ever having to beg. My neighbor, friend, and photography expert Richard Lorenz was also always on the lookout, as was my exceptionally alert research assistant, Ottavia Storer, who, unbeknownst to me, had her own collection of doggy snapshots that were quietly proffered near the end. Melissa Lee Harris, herself a Linda Connor referee, also shared her fine collection of dog snapshots, gathered mostly on trips through the Midwest.

I am also grateful for the cooperation and support of many others, including Malin Barth, Beverly Brannan, Sue Brisk, Cornell Capa, Kim Zorn Caputo, Brigitte Carnochan, Rosa Casanova, Sharyl DeAlva, Robert Delpire, Roger Eldridge, Kristin Eppler, David Ferber, Sheryl Fullerton, Agathe Gaillard, Kara Glynn, Jane Gottesman, Kathleen Grosset, Robert Gurbo, Nancy Hair, Hazel Hammond, Jenni Holder, Frances Horn, John-Paul Kernot, Leslie Lambert, Meredith Lue, Jane Marsh, Joan Merryman, Jessica Murray, Dianne Nilsen, Melissa O'Connor, Lisa Perez, Anna Roma, Daisy Sanchez, Michele Seeberger, Jeffrey Smith, Sarah Sockit, Melanie St. James, Anna Winand, and Warren Winter.

At Chronicle Books, I was very fortunate to work with editors Sarah Malarkey and Micaela Heekin as well as art director Jeremy Stout, all of whom made the usually difficult process of producing a book actually fun. And they allowed me to choose as the book's designer Jody Hanson, whose elegant work I very much admire.

Photographic Credits

All photographs are copyright the photographers or the estates listed below. No material can be reproduced without permission.

Page 2: Private collection
Page 6: Courtesy the photographer
Page 11: Private collection
Page 12: Private collection
Page 13: Private collection
Page 14: Private collection
Page 15: Collection Melissa Lee Harris
Page 16: Private collection
Page 17: Private collection
Page 18: Private collection
Page 19 (top): Collection Linda Connor
Page 19 (bottom): Collection Melissa Lee Harris
Page 20: Courtesy Lee Marks Fine Art, Shelbyville, Indiana
Page 21: Private collection
Page 22: Collection Melissa Lee Harris
Page 23: Private collection
Page 24: Collection Melissa Lee Harris
Page 25: Courtesy Scheinbaum and Russek, Santa Fe © 1981 Center for Creative Photography, Arizona Board of Regents
Page 26: Private collection
Page 27: From portfolio of Rosebud and Pine Ridge Photographs, 1922–42 Courtesy Museum of Modern Art, New York
Page 28: Courtesy the Estate of Louis Faurer
Page 29: Courtesy © Bill Brandt Archives, London

Page 30: Courtesy © the photographer
Page 31: Courtesy © Estate of Robert Capa
Page 32: Courtesy Caisse Nationale des Monuments Historiques et des Sites, Paris
Page 33: Courtesy Sistema Nacional de Fototeca, Mexico CONACULTA-INAH-SINAFO
Page 34: Private collection
Page 35: Courtesy Library of Congress
Page 36: Private collection
Page 37: Courtesy RAPHO, Paris
Page 38: Courtesy the photographer
Page 39: Courtesy the photographer and Laurence Miller Gallery, New York
Page 40: Courtesy © the photographer
Page 41: Courtesy © Estate of Robert Capa
Page 42: Collection Ottavia and Tracy Storer
Page 43: Courtesy Ursula Gropper Associates
Page 44: Photograph © 2000 Jacques Lowe
Page 45: Courtesy © the photographer
Page 46: Courtesy RAPHO, Paris
Page 47: Courtesy RAPHO, Paris
Page 48: Courtesy Magnum Photos
Page 49: Courtesy RAPHO, Paris
Page 50: Courtesy Staley-Wise Gallery, New York
Page 51: © Estate of Ilse Bing, Courtesy Edwynn Houk Gallery, New York
Page 52: Courtesy © the photographer
Page 53: Courtesy the photographer and Camera Press, London
Page 54: Courtesy Throckmorton Fine Art Inc., New York

Page 55: Courtesy © the photographer
Page 56: Courtesy Magnum Photos
Page 57: Courtesy Magnum Photos
Page 58: Collection Melissa Lee Harris
Page 59: Courtesy RAPHO, Paris
Page 61: Courtesy © the photographer
Page 62: Courtesy Magnum Photos
Page 63: Courtesy the photographer
Page 64: Courtesy Magnum Photos
Page 65: Courtesy Magnum Photos
Page 66: Courtesy the photographer
Page 67, front cover: Courtesy the photographer
Page 68: © Estate of André Kertész
Page 69: Courtesy the photographer
Page 70: Courtesy the photographer
Page 71: Courtesy the photographer
Page 73: Courtesy the photographer
Page 74: Courtesy Magnum Photos
Page 75: Courtesy the photographer
Page 76: Courtesy the photographer
Page 77: Courtesy the photographer
Page 78: Courtesy Mary Ellen Mark
Page 79: Courtesy the artist and Fraenkel Gallery, San Francisco
Page 80: Courtesy the photographer
Page 81: Courtesy Mary Ellen Mark
Page 82: Courtesy the photographer
Page 83: Courtesy the photographer
Page 84: Courtesy Magnum Photos
Page 85: Courtesy Magnum Photos
Page 86: Courtesy the photographer and the Anderson Collection
Page 87: Courtesy the photographer and the Anderson Collection
Page 88: Courtesy the photographer

Page 89: Courtesy the photographer
Page 90: Courtesy the photographer
Page 91: Courtesy the photographer
Page 92: Courtesy the photographer
Page 93: Courtesy the photographer
Page 94: Courtesy the photographer
Page 95: Courtesy the photographer
Page 96: Courtesy the photographer
Page 97: Courtesy the photographer
Page 98: Courtesy the photographer
Page 99: Courtesy Ursula Gropper
 Associates, Sausalito, California
Page 100: Courtesy the photographer
Page 101: Courtesy the photographer
Page 102: Courtesy the photographer
Page 103: Courtesy the photographer
Page 104: Courtesy the photographer
Page 105: From *I Hear the Leaves and
 Love the Light*, Nazraeli Press, 1999
 Courtesy the photographer
Page 106: Courtesy the photographer and
 San Francisco Museum of Modern Art
Page 107: Courtesy the photographer
Page 108: Courtesy the photographer and
 Robert Koch Gallery, San Francisco
Page 109: Courtesy the photographer
Page 111: Courtesy the photographer
Page 112: Courtesy the photographer
Page 113: Courtesy the photographer
Page 114: Courtesy the photographer and
 Robert Mann Gallery, New York, and
 Howard Yezerski Gallery, Boston

Page 115: Courtesy the photographer and
 Robert Mann Gallery, New York, and
 Howard Yezerski Gallery, Boston
Page 116: Courtesy the photographer and
 Robert Mann Gallery, New York, and
 Howard Yezerski Gallery, Boston
Page 117: Courtesy the photographer
Page 118: Courtesy Magnum Photos
Page 119: © Sally Mann, Courtesy
 Edwynn Houk Gallery, New York
Page 121: Courtesy the photographer
Page 122: Courtesy the photographer
Page 123: Courtesy the photographer
Page 124: Courtesy the photographer
Page 125: Courtesy the photographer
Page 126: Courtesy The Halsted Gallery,
 Birmingham, Michigan
Page 127: Courtesy © the photographer
Page 128: Courtesy the photographer
Page 129: Courtesy the photographer
Page 130: Courtesy the photographer
Page 131: Courtesy the photographer
Page 133: © Annie Leibovitz/Contact
 Press Images
Page 134: Courtesy the photographer
Page 135: Courtesy Rena Bransten Gallery,
 San Francisco
Page 136: Courtesy SIPA Press
Page 137: Courtesy the photographer and
 the Anderson Collection
Page 138: Courtesy Lee Marks Fine Art,
 Shelbyville, Indiana

Page 139: Courtesy the photographer/
 Delta Time
Page 140: Courtesy the photographer
Page 141: © 1999 Steven Shames/Matrix
Page 142: Courtesy the photographer
Page 143: Courtesy Magnum Photos
Page 145: Courtesy the photographer
Page 146: Courtesy the photographer
 and Ariel Meyerowitz Gallery, New York
Page 147: Courtesy the photographer
 and Ariel Meyerowitz Gallery, New York
Page 148: Courtesy the photographer
Page 149: Courtesy the photographer
Page 150: Courtesy the photographer
Page 151: Courtesy Blind Spot Artist
 Representation, New York
Page 152: © 1991 Langdon Clay
Page 153: Courtesy the photographer
Page 154: Courtesy the photographer
Page 155, back cover: Courtesy Robert
 Mann Gallery, New York, and Howard
 Yezerski Gallery, Boston
Page 155: Private collection
Page 156: Courtesy the photographer
Page 160: Courtesy the photographer

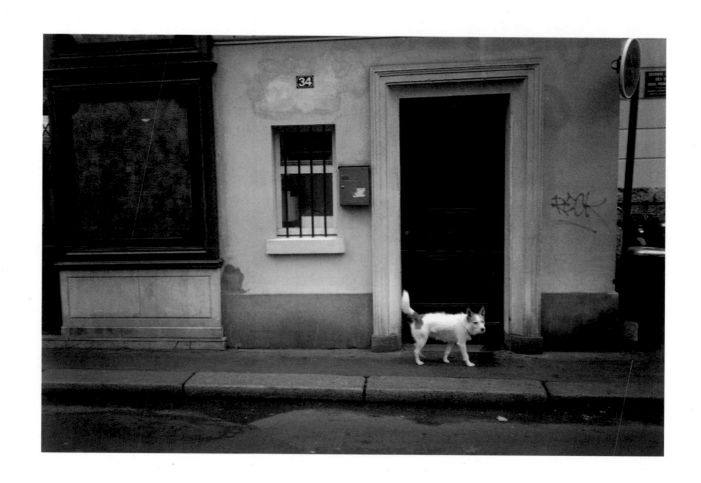

Paris, 1993